HOWE·LIBRARY

HANOVER
NEW HAMPSHIRE

ARCTIC VISIONS

Encounters at the Top of the World

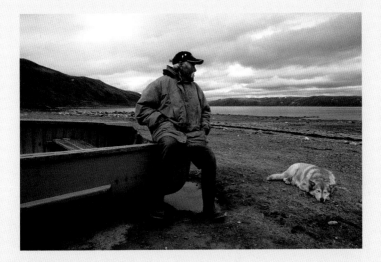

STEPHEN GORMAN

ARCTIC VISIONS

Encounters at the Top of the World

STEPHEN GORMAN

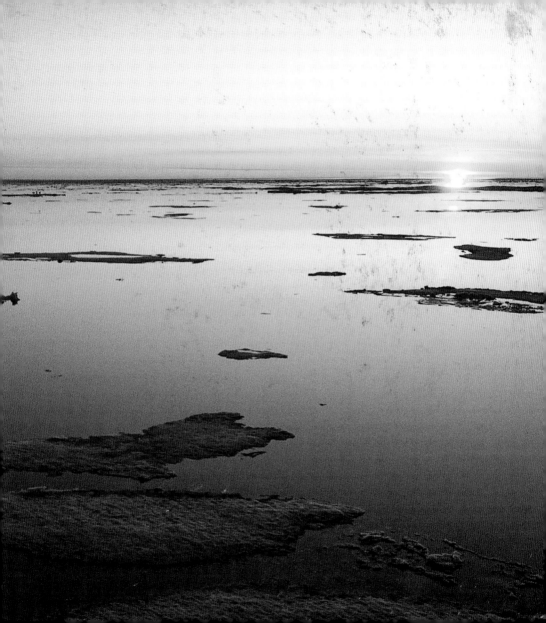

STEPHEN**GORMAN**
THE ART OF THE WILD

504 Hawk Pine Road
Norwich, Vermont 05055
802-649-8789
Steve@StephenGorman.com
www.stephengorman.com

First Edition

Library of Congress Control Number: 2010903691

Printed in China

ISBN: 978-0-9826885-0-2

Book design by Dede Cummings
Printed on glossy art paper.

Sources for the quotes, with thanks, from *Living Arctic* and www.nunavut.com.
Hugh Brody, *Living Arctic, Hunters of the Canadian North*, London: Faber and Faber, 1987

PAGE 1, FIRST TITLE: LOOK TO THE FUTURE, REMEMBER THE PAST / *Kangiqsujuaq, Nunavik, Canadian Arctic*
By the shores of Hudson Strait, an Inuit elder told stories about hunting, fishing, and daily life in this remote
former Hudson Bay Company outpost. He spoke only Inuktitut, so I was fortunate when a young hunter—who
called the older man his "grandfather" even though they were not related—translated for me. All the while the
elder's dog snoozed peacefully at his feet.

TITLE PAGE SPREAD: IN FRANKLIN'S WAKE / *Northwest Passage, Canadian Arctic*
The sun sets over the icy waters of Peel Sound in the Canadian Arctic. Separating Prince of Wales Island and
Somerset Island, Peel Sound is shallow and frequently impassable due to ice. Sir John Franklin's ships *Erebus* and
Terror sailed through here before becoming permanently trapped by ice in Victoria Strait in 1846.

COVER IMAGE: POLAR MADONNA / *Ungava Bay, Canadian Arctic*
In a rare close encounter, I came upon this polar bear mother and her two cubs making a long distance swim in
Ungava Bay. The cubs actually hold on to their mother's back with their front paws while she swims. For me,
this image has become a powerful symbol of hope for the future of the Arctic.

CONTENTS

FOREWORD

NOT SINCE THE GLORY DAYS OF POLAR EXPLORATION in the mid-1800s has the Arctic captured the globe's imagination as it does now. Scientists, politicians, industrialists and environmentalists are watching and debating the effects of climate change on this pristine corner of the world. As in Franklin and Ross' era, the Arctic's prize now is access to riches—only this time, it offers not just a shipping route but also the oil, gas and minerals that lie beneath the thawing sea ice and permafrost. And even more significantly, this time in the Arctic it is the indigenous people, the Inuit, who are in charge. In ways unimaginable a century-and-a-half ago, they are guiding both the protection and development of their fragile homeland.

My first trips to the Arctic as a freshly minted research engineer found me camped on the sea ice alongside Inuit colleagues. With them, I watched the long days of spring arrive and the leisurely sun bathe its light on basking seals, prowling polar bears and beluga whales swimming beside the floe edge. I felt blessed: the landscape was so vast, the air so clear, the lifestyle so inspiring. But, much as I wanted to share this experience with my friends and family in the south, I could never find the words or take the photos to do it justice.

All these years later, I'm still partnered with the Inuit—and, with them, still striving to share the Arctic's wonders. At Cruise North we have the privilege of introducing the Far North's marvellous culture, fascinating wildlife and stunning scenery to curious, committed guests from around the world. Our visitors are hosted by Inuit and other professionals, who lend their boundless Arctic knowledge and experience. Stephen Gorman is one of those professionals, a photographer with true skill and passion, whose

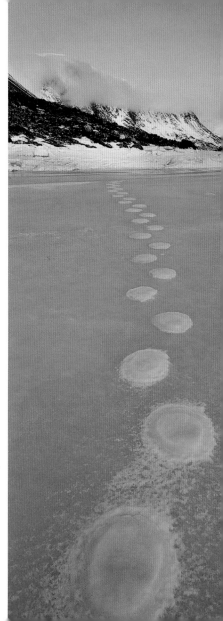

artful compositions capture the region's marvels in the way I'd always wished I could.

I feel the time is right for this book. Now that the Arctic has the world's attention, people need to see it as it really is: authentic, free from political spin, devoid of child-like stereotypes. This is what Stephen's work does—and this is what the Inuit aim to do, through companies like Makivik, which owns Cruise North. They are tackling the Arctic's challenges head-on, with the confidence and practical wisdom that come from thousands of years of living in this beautiful but often-unforgiving place. And at the same time, they are welcoming those from elsewhere to see and touch their homeland. Through this combination of smarts and guts and grace, they are fashioning a legacy in the Arctic not just for generations of Inuit, but for the world at large.

—DUGALD WELLS,
President, Cruise North Expeditions

TRACK OF THE ICE BEAR / *Torngat Mountains, Nunatsiavut, Canadian Arctic*
Footprints the size of dinner platters mark the passage of a polar bear over the turquoise ice of Saglek Fjord. The fjord was covered in snow when the bear passed through, and as he walked, his great weight compressed the snow into hard white ice. When the ceaseless wind scoured the rest of the snow off the surface of the fjord, these huge imprints remained welded to the surface.

ARCTIC VISIONS

Encounters at the Top of the World

THE BOW OF THE ICE-HARDENED EXPEDITION VESSEL *Lyubov Orlova* sliced through the placid waters of St. John's Harbor on the southeast coast of Newfoundland. Sailing north in the wake of Bartlett, Peary, and other polar explorers, our journey north to the top of the world had begun.

I traveled throughout the Canadian Arctic aboard the *Orlova* as photographer for Cruise North Expeditions, an Inuit owned and operated educational and adventure travel company. This position gave me an unprecedented opportunity to photograph some of our planet's most remote landscapes and most magnificent wildlife populations in the least-known and least-explored portion of our planet. As I journeyed over the surface by ship, I accessed places that haven't been visited by travelers in years, decades, or even perhaps at all.

Heading up the coast of Labrador, my shipmates and I explored the uncharted fjords where the glacier-carved Torngat Mountains rise from the sea. Rounding the northern tip of Labrador, we sailed into Ungava Bay, Hudson Strait, and Hudson Bay. Turning north into Davis Strait we coasted the mountains and fjords of Baffin Island. Crossing the Arctic Circle, we sailed into the Northwest Passage and Lancaster Sound—a place called the "Serengeti of the Arctic" for its rich populations of narwhal, beluga, walrus, muskox, and polar bear. Reaching Cornwallis Island we were 540 miles north of the Arctic Circle, deep in the labyrinth of High Arctic islands and following the route of the fabled, lost

expedition of Sir John Franklin, whose ships *Erebus* and *Terror* became trapped in the ice in 1847 and were never seen again.

Each day we stepped ashore to explore and photograph the towering mountains, fjords, glaciers, and ice caps. We spent time in remote Inuit villages learning about modern and traditional ways of life in the Arctic. Stopping at historic sites such as Beechey Island, we investigated the graves of Franklin's sailors who still lie buried in the frozen gravel of the polar desert. At Beechey the mystery surrounding the Franklin expedition still prevails. Here, evidence of the cursed expedition was discovered, but no trace of the ships has ever been found.

The Arctic remains a vast, seemingly pristine and uninhabited region, the last place on earth unaltered by the hand of man. For most people it is a vast unknown and uncharted region, a blank canvas upon which we can project our dreams and desires. As such, the distinguished Canadian historian Robert McGhee calls it *The Last Imaginary Place.*

But the Arctic is also a real place, a landscape with a rich human history, a beloved homeland to the Inuit, and a region filled with precious natural resources coveted by developers, industrialists, corporations, and rival nations. As the world turns its attention north, the future of the Arctic hangs in the balance.

From the bow of the *Orlova,* I looked north to the many adventures that lay ahead. I hope you enjoy the photographs from those encounters at the top of the world.

—STEPHEN GORMAN

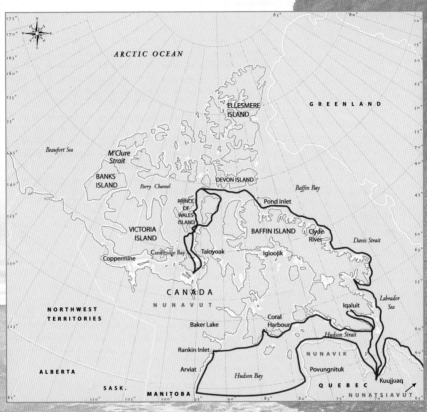

CRUISE NORTH EXPEDITION ROUTES TRAVELED BY THE PHOTOGRAPHER.

Nunavut, meaning "our land" in Inuktitut, is the newest and largest federal territory of Canada. Formerly a part of the Northwest Territories, it was officially created on April 1, 1999.

Nunavik, meaning "the place to live" in Inuktitut, comprises the northern third of Quebec. It is the Inuit homeland covered by the first modern aboriginal land claim agreement in Canada, and is soon to become a self-governing region within the province of Quebec.

Nunatsiavut, meaning "our beautiful land" in Inuktitut, is an autonomous area in northern Labrador adjacent to Nunavik established in 2005.

THE LAND

*The survival of Inuit depended solely on the land and waters
and the wildlife that they provide.
The relationship between the Inuit and the land was one,
like a newborn baby to her mother.*

—BRIAN AGLUKARK, ARVIAT

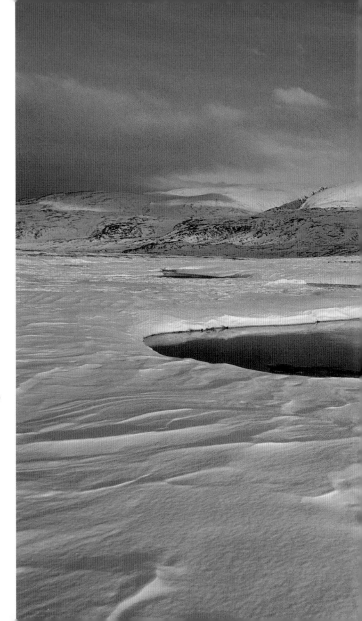

The Spirit Mountains
*Torngat Mountains, Nunatsiavut,
Canadian Arctic*

The Inuit word "Torngat" has
been translated as either "the
spirit mountains" or "where the
evil spirit dwells." The mountains
form the boundary between
Nunatsiavut (northern Labrador)
and Nunavik (northern Quebec),
and are formidable, austere, and
remote. Although little known to
outsiders and largely unexplored
to this day, the Torngats were
likely the first North American
range seen by Europeans when
the Vikings crossed Davis Strait
from Greenland and headed
south to Markland and Vinland
around 1,000 A.D.

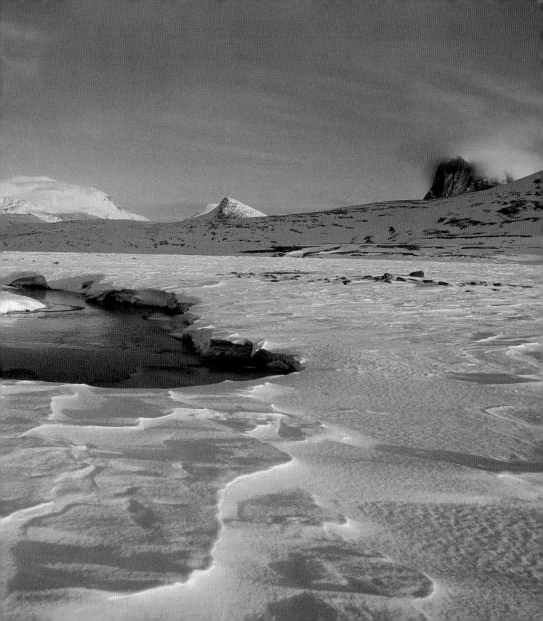

SUNCUPS

Torngat Mountains, Nunatsiavut

A vast field of suncups marches across the summer snow towards a cloud-capped summit in the Torngat Mountains. Suncups are depressions in the snow surface formed by melting and evaporation caused by the heat of the sun.

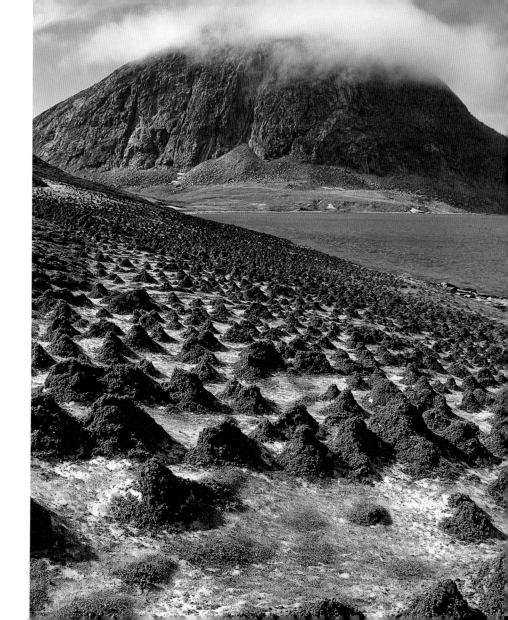

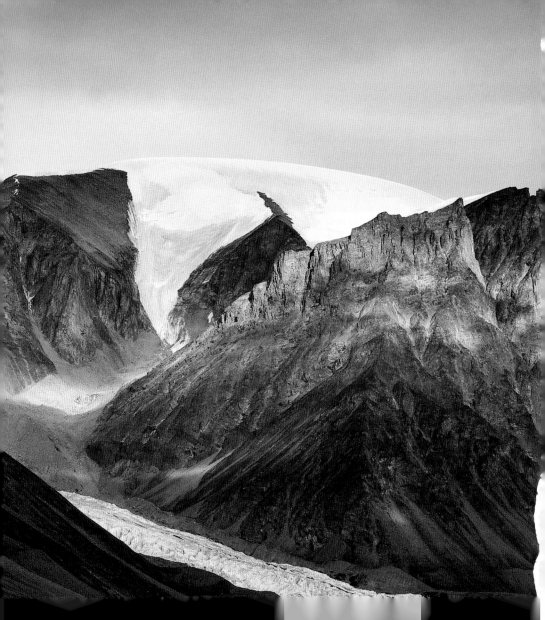

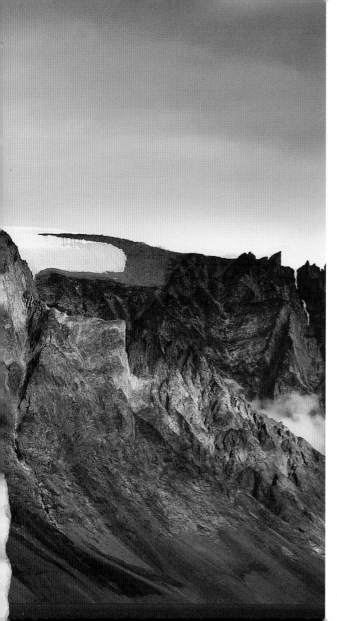

CARVED BY THE ICE

Baffin Island, Canadian Arctic

Sharp, multi-colored cliffs erupt from the ice-blue waters of a fjord on the east coast of Baffin Island. Above the cliffs, the peak is capped by a glacial remnant of the last Ice Age. Below the summit, a glacier flows from the icecap down to meet the waters of the fjord.

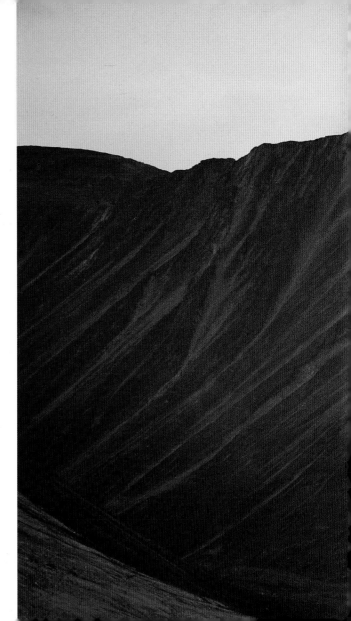

RAMPARTS OF THE ICE AGE
North Coast of Baffin Island,
Nunavut, Canadian Arctic
Just to the east of the Inuit village
of Pond Inlet, or Mittimatalik in
Inuktitut, a deep glaciated valley
recedes into the rugged mountains
of the Arctic Cordillera. This
stunning mountain chain runs
southward from Ellesmere Island
down along the entire eastern edge
of Baffin Island to the Torngat
Mountains in Nunatsiavut.

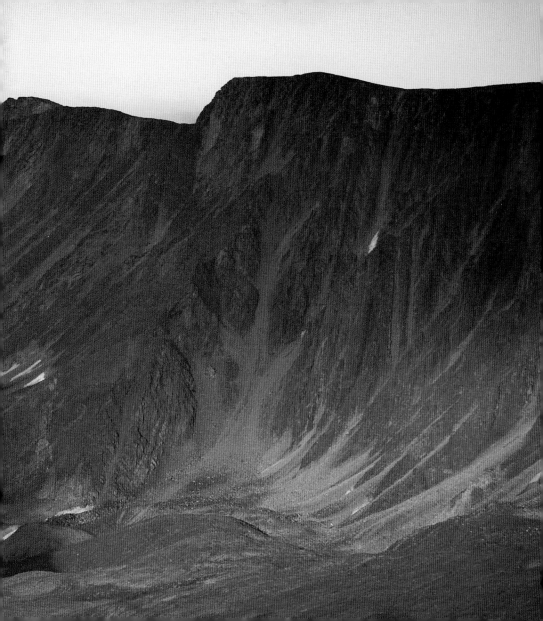

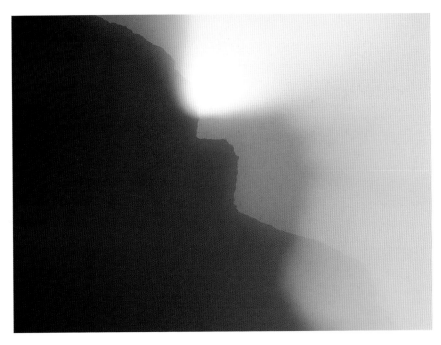

SUNBURST
Nunavut, Canadian Arctic
Traveling through the choppy seas at the edge of an island, I could see only a few yards through the thick fog. And then, looking up to the top of the cliff towering more than a thousand feet above, I witnessed the sun burning through the fog and creating this unearthly special effect.

STRANDED ICE BLOCKS
Nunavut, Canadian Arctic
Hiking along the beach of an arctic island, I came upon these giant ice blocks measuring about eight feet high and weighing several tons. This sculpture garden was created when the tide washed them ashore and stranded them here.

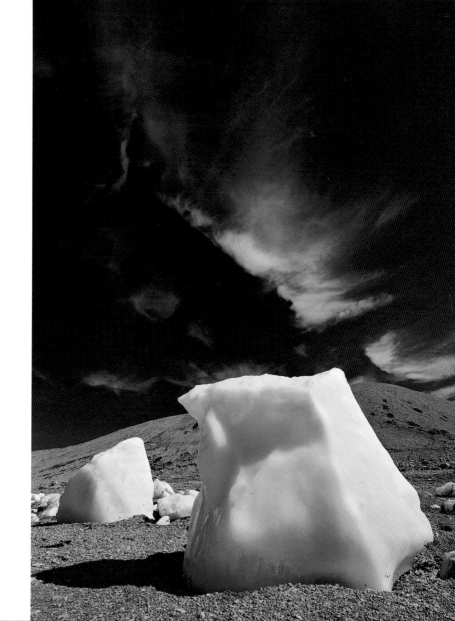

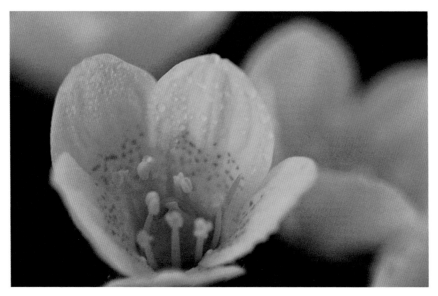

Arctic Poppies / *Marble Island, Nunavut*

Arctic poppies prefer growing among the rocks because the stones absorb heat from the sun while also providing protection from the wind and moist shelter for the roots. These flowers grew on Marble Island, the site of one of the Arctic's greatest unsolved mysteries. Why, in 1719, did captain James Knight and the 40 crew members of the Hudson Bay Company ships *Albany* and *Discovery* starve to death here, in sight of the mainland and only four day's travel from an HBC outpost?

Sirmilik—The Place Of Glaciers

Sirmilik National Park, Bylot Island

Sirmilik is an Inuktitut word meaning "the place of glaciers." Trekking here in Sirmilik National Park on Bylot Island in the Canadian High Arctic, I felt like a witness to the ice ages, for the landscape was scoured by both continental ice and localized alpine and cirque glaciers. Everywhere were freshly carved summits, ridges, and valleys. Mountain peaks called nunataks protruded from the icefields, while glacial melt water pools reflected the ranges, ice, and sky.

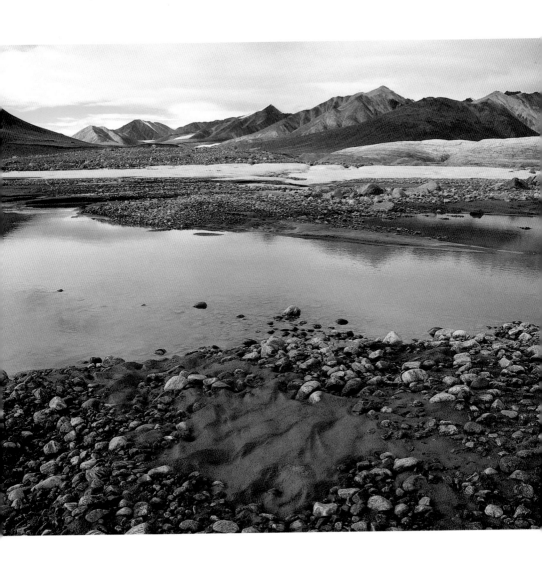

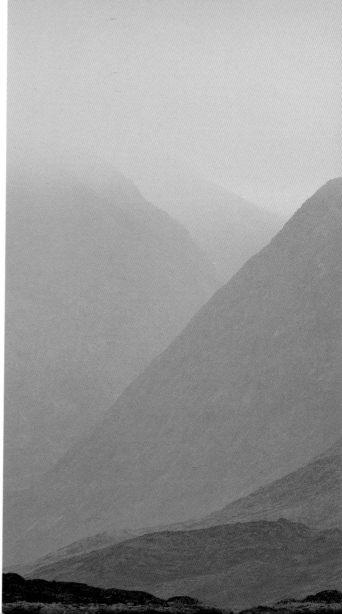

THE CLIFFS OF PANGNIRTUNG
Pangnirtung Fjord, Baffin Island
Pangnirtung is situated in a spot
of almost surreal beauty. The
frigid waters of the fjord form
a perfect small boat harbor, and
in all directions sheer cliff faces
reminiscent of Half Dome and El
Capitan in Yosemite National Park
rocket heavenward from the sea.

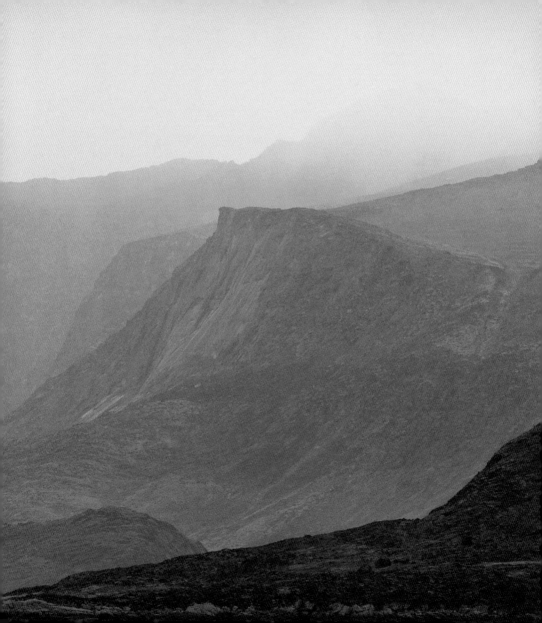

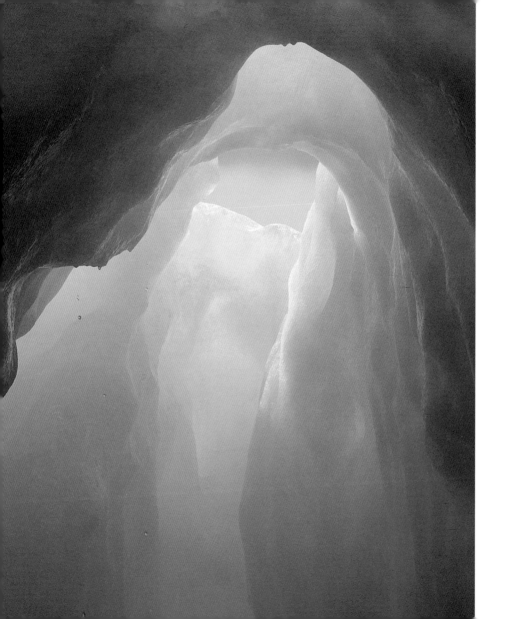

ARCTIC DREAMS

Ungava Bay, Canadian Arctic

While hiking along the shoreline of a remote Arctic island, keeping an eye out for polar bears, I came upon an iceberg stranded at the high tide line. Walking around it, I saw this window in the ice. The sun was positioned directly above and slightly behind, sending a shaft of ethereal light down through the turquoise opening.

BEECHEY ISLAND
Northwest Passage, Canadian Arctic
If the Arctic has a most
sacred place, this is it. This
is where the mystery begins,
the last known position of
the lost Franklin Expedition.
Before Franklin set sail from
England, Sir John Ross
had urged him to leave a
message in a cairn outlining
his future plans. No such
message has ever been found,
and for years search parties
could only guess which
of the labyrinthine routes
the explorer took before
vanishing.

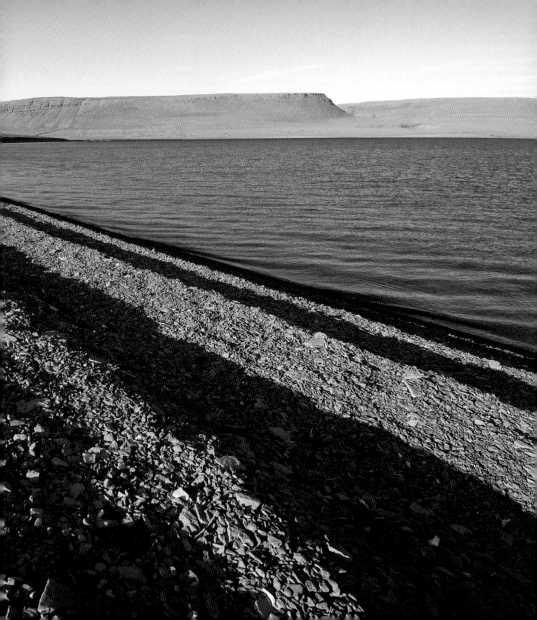

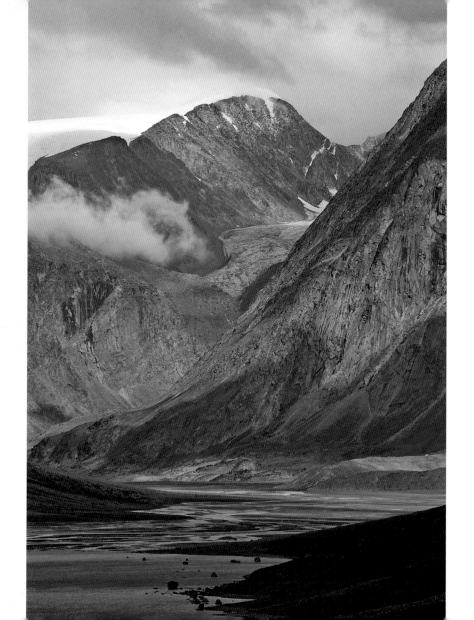

THE VIKING GARDEN / *Cape St. Charles, Labrador*

Cape St. Charles on the coast of Labrador is the easternmost point on the North American mainland. According to the sagas, Leif Eriksson and the Vikings sailed across the Labrador Sea from Greenland to cut timber in this place they called "Markland." While walking on the tundra, I spied this little arctic sandwort. I decided it was a soft focus kind of morning. And so I moved in until the edges of the petals began to blur, reflecting the mood of the day.

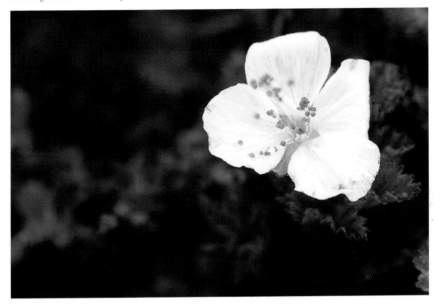

MOUNTAIN STRONGHOLD (LEFT) / *Baffin Island, Nunavut*

Much of eastern Baffin Island is characterized by soaring granite peaks, glaciers flowing from the massive Penny Ice Cap, and magnificent fjords cleaving their way deep into the heart of the mountains. Larger than California, the entire population of Baffin Island would not fill the seats at Madison Square Garden in New York City.

MIDNIGHT IN THE NORTHWEST PASSAGE (OVERLEAF) / *Lancaster Sound, Canadian Arctic*

The midnight sun casts an ethereal glow across the waters of Lancaster Sound and the entrance to the Northwest Passage. Beyond, a turquoise glacier flows into the Sound from the mesas and buttes of the high polar desert interior of Devon Island.

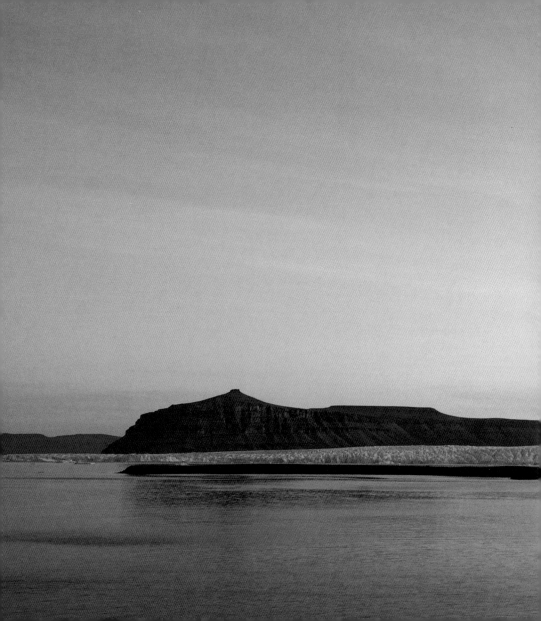

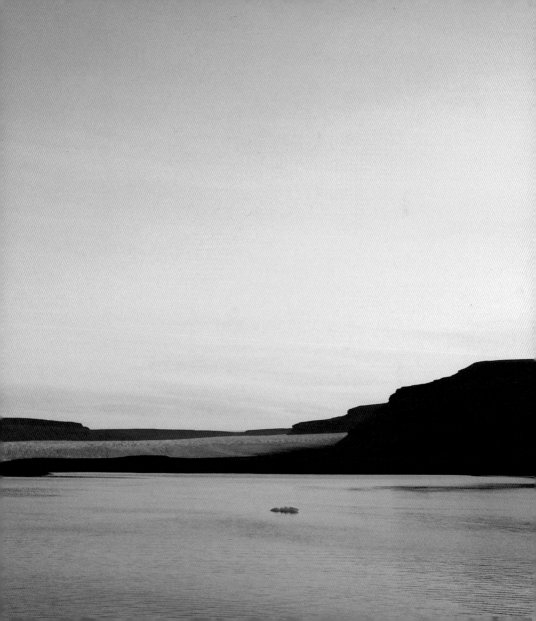

ROCK ART
Ungava Peninsula, Nunavik

Wandering up a nameless Arctic valley at the northern tip of Nunavik, I was disappointed that the day was overcast and misty. The flat light precluded any opportunities for expansive landscape photography. That's when I looked down and noticed what I hadn't before—that nature was providing me with an extravagant show of rock art right at my feet!

ICEBERG OFF BYLOT ISLAND
Eclipse Sound, Canadian Arctic

An iceberg floats in the cobalt seas off the rugged coast of Bylot Island in the Canadian High Arctic. "The landscape conveys an impression of absolute permanence," wrote the ethnographer Edmund Carpenter. "It is not hostile. It is simply there—untouched, silent, and complete. It is very lonely, yet the absence of all human traces gives you the feeling you understand this land and can take your place in it."

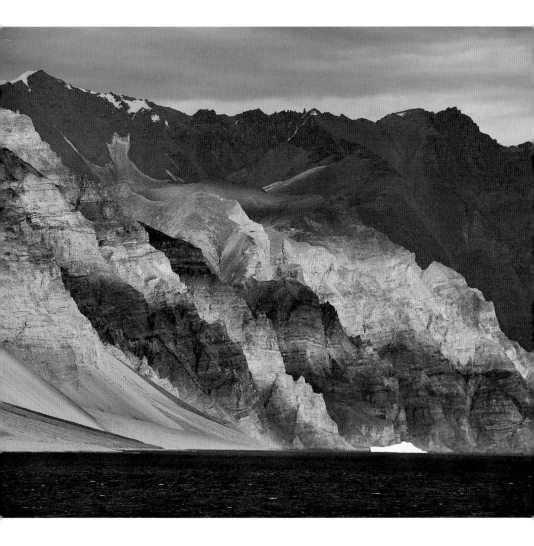

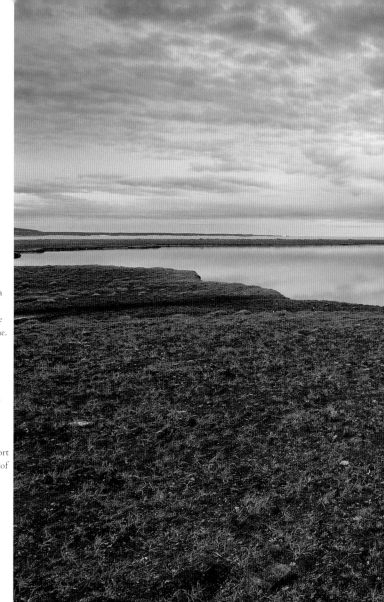

THE TUNDRA POND
Baffin Island, Nunavut
The Arctic tundra is a
vast area of beautiful,
stark landscapes above
the continental treeline.
The soil beneath the
tundra is permafrost,
making it impossible
for trees to grow.
Instead, Arctic tundra
can only support low
growing plants such
as moss, heath, and
lichen. During the short
summer the top layer of
the permafrost melts,
and as a consequence
the tundra is covered
with innumerable
marshes, lakes, ponds
and streams.

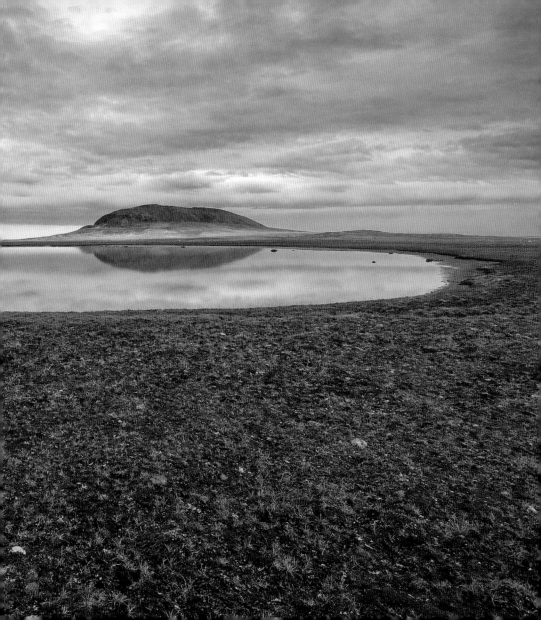

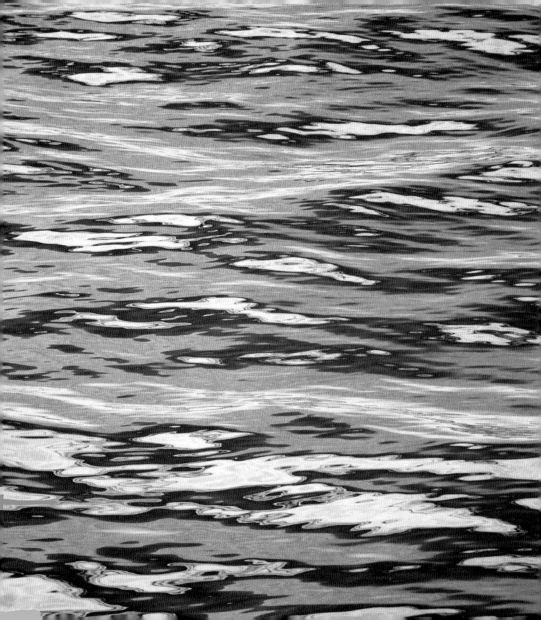

THE SEA

I like walking in the water, and watching seals.
I like going hunting, going on a speedboat.
I like going dancing, but best of all I like to fish.

—KATIE ZARPA, NAIN

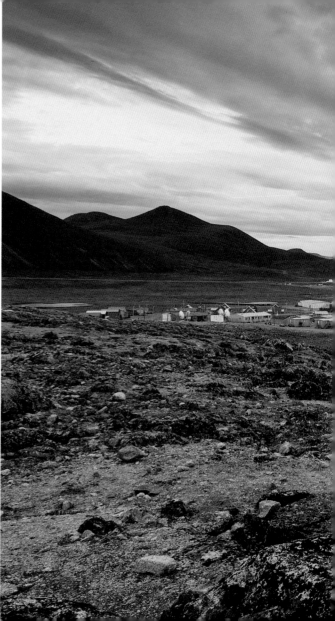

Hudson Bay
Reflections
(previous page)
Hudson Bay, Canadian Arctic
Until I began traveling in the Arctic I
rarely thought about producing abstract
art—works that seemed to me to
contain few recognizable forms from
the physical world, and which instead
placed greater emphasis on line, color,
shape, and texture. But my appreciation
for the abstract changed when I first
witnessed the patterns of Arctic waters
such as these in Hudson Bay. Now when
traveling the Arctic, I am continually
entranced by the shape-shifting magic
of northern waters.

Qikiqtarjuaq
Qikiqtarjuaq, Nunavut
In the 1950s and 1960s the nomadic
Inuit abandoned their autonomous
lives as sea mammal hunters and
trappers living off the bounty of
the marine ecosystem. Relocating to
permanent villages and transitioning
to a wage economy with scarce jobs
has been a wrenching change. In the
nomadic days all Inuit were fully
employed in the day-to-day business
of survival. The strain unemployment
places on Inuit society remains one
of the most problematic legacies of
the transition to a settled community
way of life.

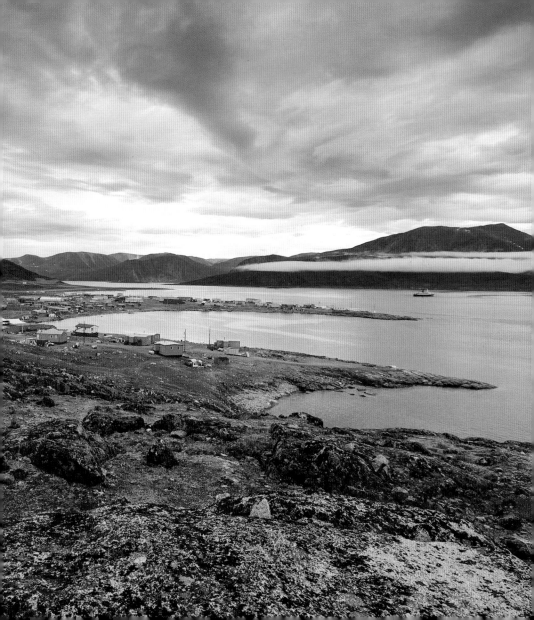

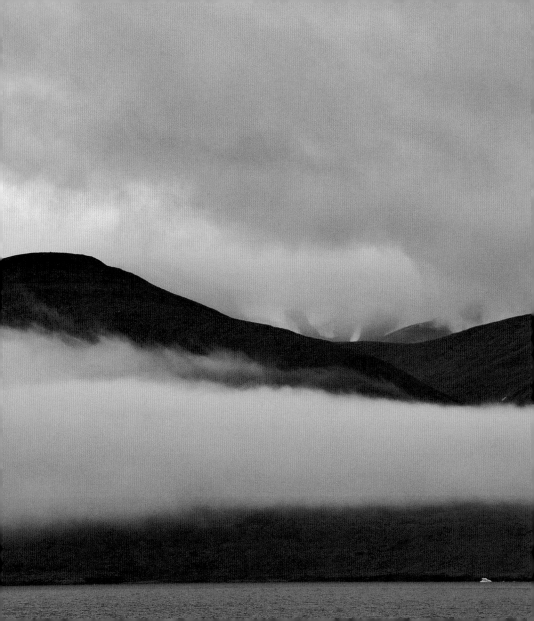

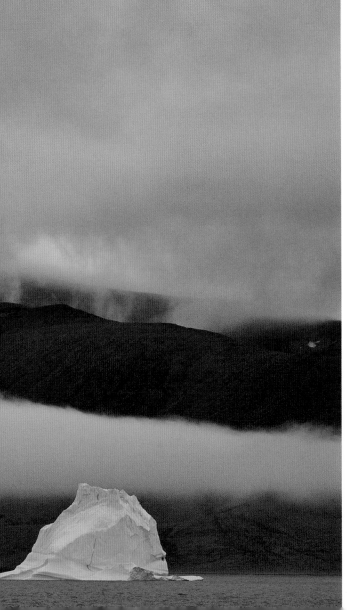

MIST AND MYSTERY
Baffin Island, Nunavut

A thousand years ago, Viking explorers set sail from their new colonies in Greenland. Crossing Davis Strait, they discovered a new land they called Helluland—a place we now know as Baffin Island. Here they encountered the Dorset—a people who preceded the Inuit in the eastern Arctic. Approaching Baffin Island by sea on a day shrouded in mist and mystery, it was easy to imagine what the Vikings saw from their longboats that day.

PINNACLED ICEBERG, LABRADOR SEA
Nunatsiavut Coast, Canadian Arctic

Most of the icebergs in the North Atlantic break off from some 100 iceberg producing glaciers along the Greenland coast, while others originate in the eastern Canadian Arctic. Icebergs may travel thousands of miles before they melt. Some long distance voyagers have drifted as far as Bermuda and even Ireland before melting completely.

ROCK AND ICE (OVERLEAF) / *Davis Strait, Canadian Arctic*

An iceberg drifts off the shore of Monumental Island in Davis Strait, the channel separating Baffin Island from Greenland. Remote, austere, and rarely visited, Monumental Island is a favorite haul-out for walrus and polar bears.

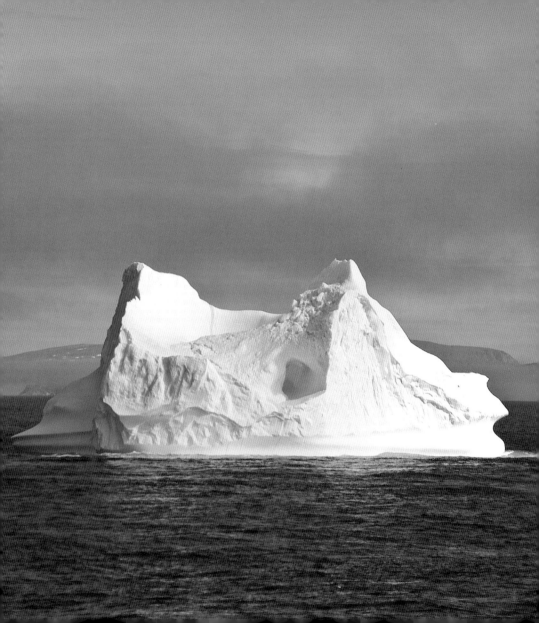

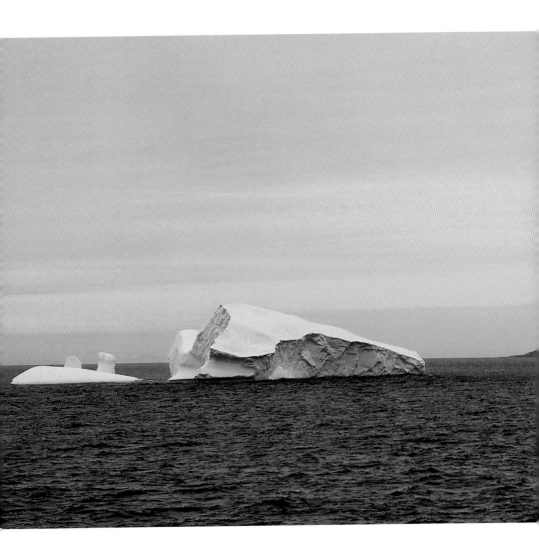

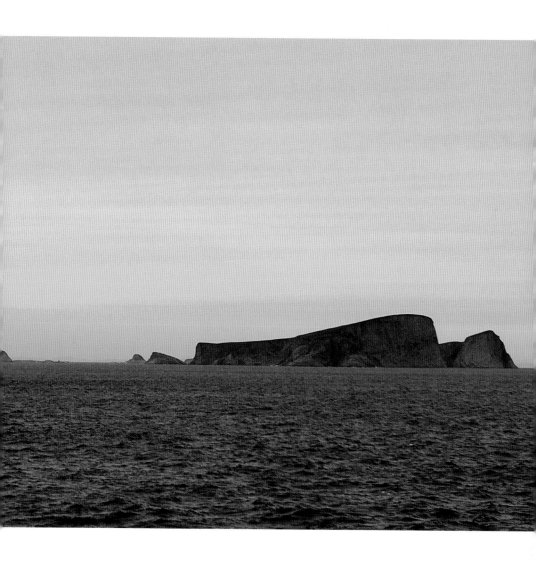

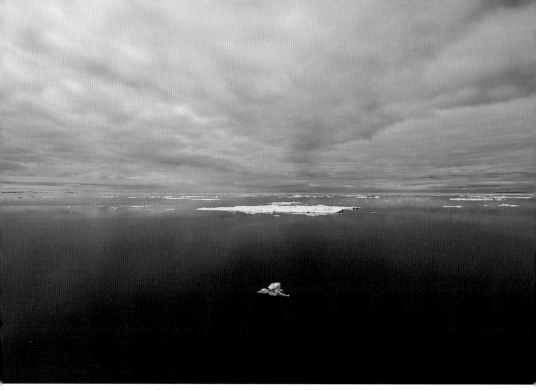

BETWEEN SEA AND SKY / *Hudson Strait, Canadian Arctic*
Sailing west into the ice toward Hudson Bay, I was seeing exactly what Henry Hudson saw in 1610 aboard
the British ship *Discovery* when he first ventured into these unknown waters. Initially believed to be the fabled
Northwest Passage, Hudson Strait connects the Labrador Sea with Hudson Bay, providing sea access into the
heart of the Canadian Arctic. Although ice-choked most of the year, the strait features leads of open water that
often create dramatic atmospheric conditions.

CLOSE ICE OFF CAPE DORSET / *Near Cape Dorset, Baffin Island*
While attempting to sail to Cape Dorset in July, the *Orlova* was stopped by ice cover of 7/10.
In the parlance of experts, floating ice in this "seven-ten" concentration—composed of floes mostly
in contact—is called "close ice." Moments after taking this photograph, I watched a polar bear
swimming the narrow leads through the ice, hunting for seals.

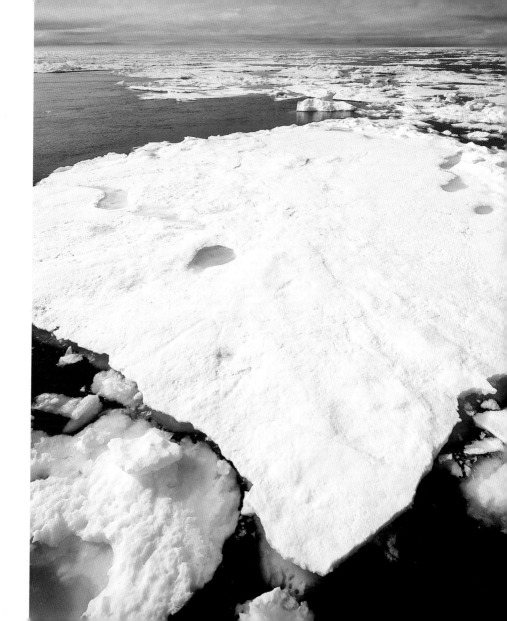

WHERE FRANKLIN WINTERED

Beechey Island, Nunavut

The Cruise North Expeditions vessel *Lyubov Orlova* tugs at anchor in the harbor at Beechey Island, precisely where Sir John Franklin's ships *Erebus* and *Terror* were locked in the ice during the winter of 1845-46. The graves of three sailors who died during that long night in the ice are located on the beach above the waterline. The following year the Franklin Expedition disappeared off the coast of King William Island, never to be seen again.

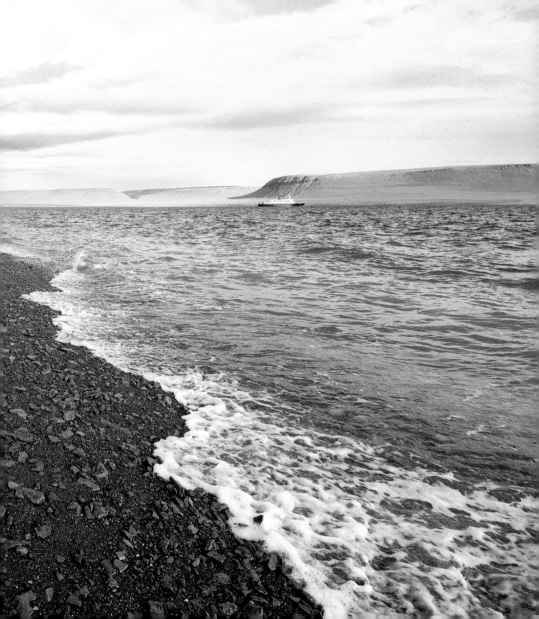

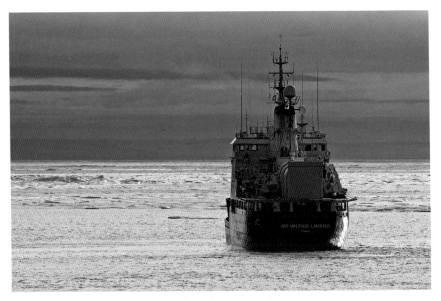

ICEBREAKER IN THE NORTHWEST PASSAGE / *Franklin Strait, Canadian Arctic*
The Canadian icebreaker *Sir Wilfred Laurier* cuts a lane through the ice of Franklin Strait in the Northwest
Passage. Canada is increasingly concerned about exercising national sovereignty over the waters of the
Arctic Archipelago as the world's attention turns North in search of lucrative natural resources and
potential cost-saving shipping lanes across the top of the world.

AURORA BOREALIS / *Gabriel Strait, Canadian Arctic*
As I stood in the cold dark silence the faint shimmer quickly grew into a gossamer curtain of fierce
green light stretching across the sky from horizon to horizon. The fabric undulated and unfolded in
graceful lateral movements, rippling and waving like a banner in a gentle breeze. Every so often the
curtain snapped like a whip, igniting startling red flashes that erupted and vanished.

BLUE BERG,
VERMILION SKY
*Hudson Strait,
Canadian Arctic*
A tabular blue
iceberg floats
upon a vermilion
sea under a
vermilion sky.
Arctic sunsets
such as this one
produce some
of the most
intensely vivid
and colorful skies
I have ever seen.

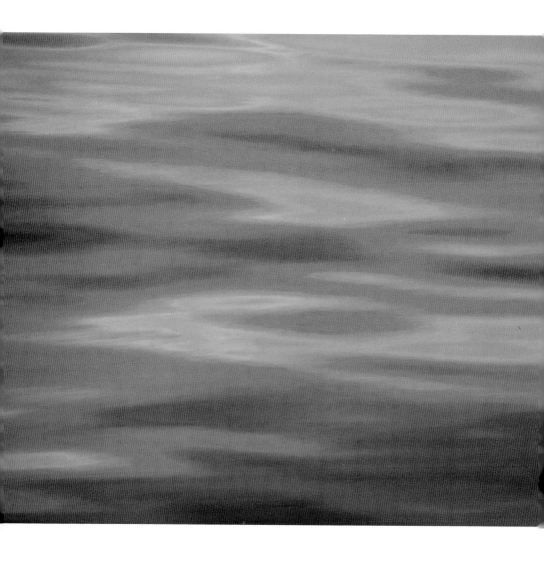

WATER FIRE
Hudson Strait, Canadian Arctic

The most astonishing sunsets I have ever seen are those reflected in Arctic waters on placid evenings when there is no wind and the seas are calm. As the sun sets it skips across the watery horizon, and the low angled rays touch only the tops of the tiny wavelets. The shallow troughs between the wavelets remain in shadow and reflect the blue of the sky above. The effect is of a richly colored, ever-changing abstract painting.

ARCTIC EXPLORERS (THIS PAGE)
Hudson Strait, Canadian Arctic

Travelers aboard the Cruise North Expeditions ship *Lyubov Orlova* stand at the bow rail to photograph the intensely colorful sunset waters of Hudson Strait.

TURQUOISE ICEBERG IN CROKER BAY (OVERLEAF)
Devon Island, Northwest Passage

On a sparkling morning, an exquisite iceberg floats off the south coast of Devon Island near the foot of the massive glacier that calved it.

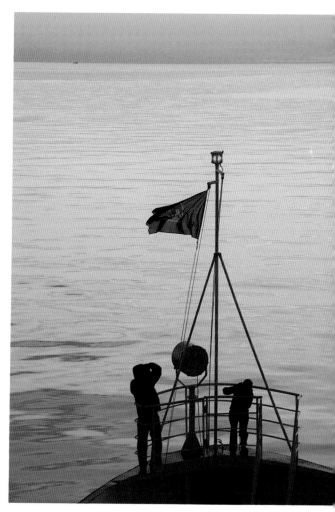

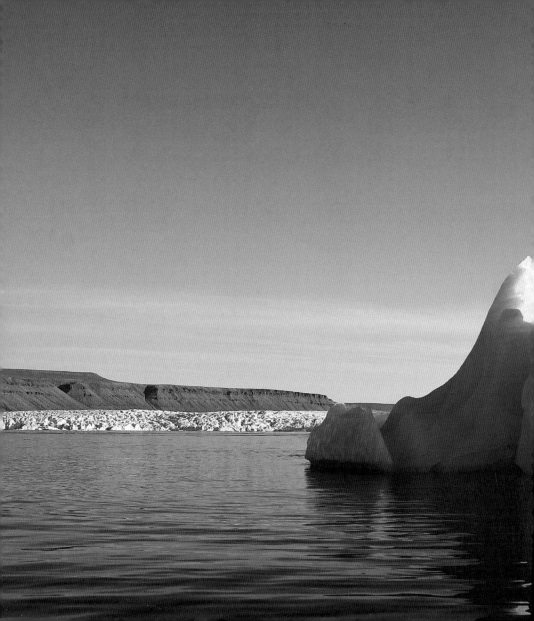

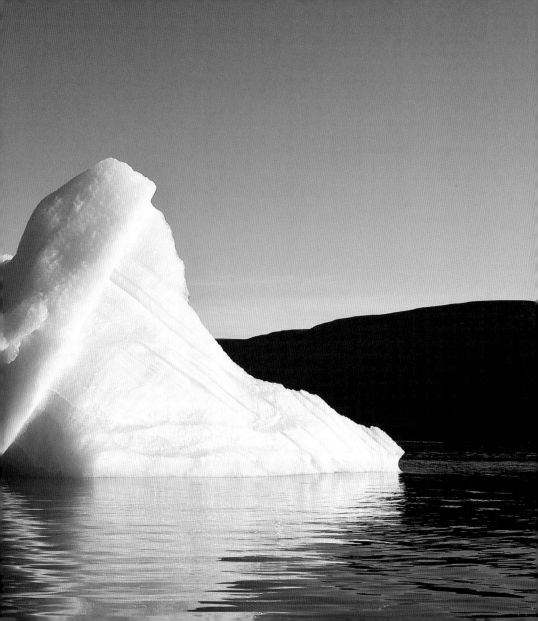

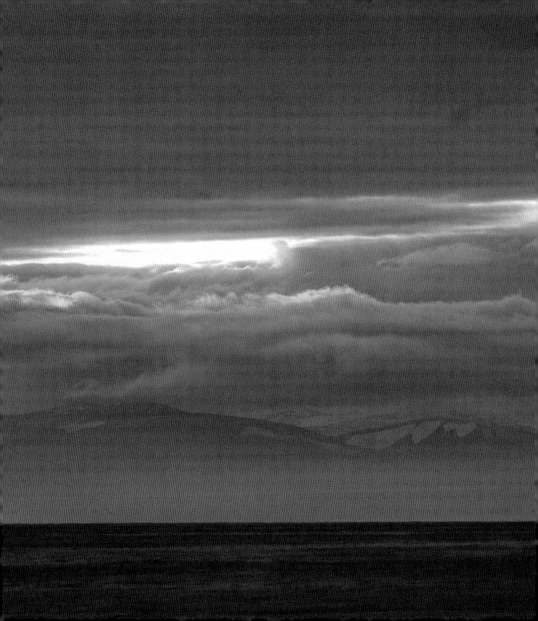

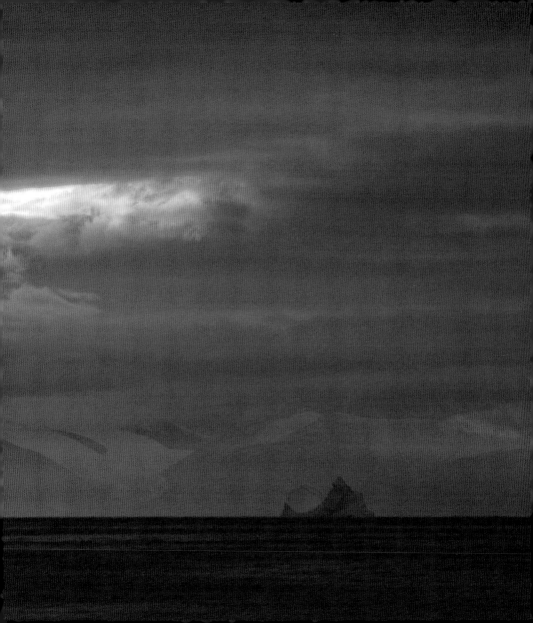

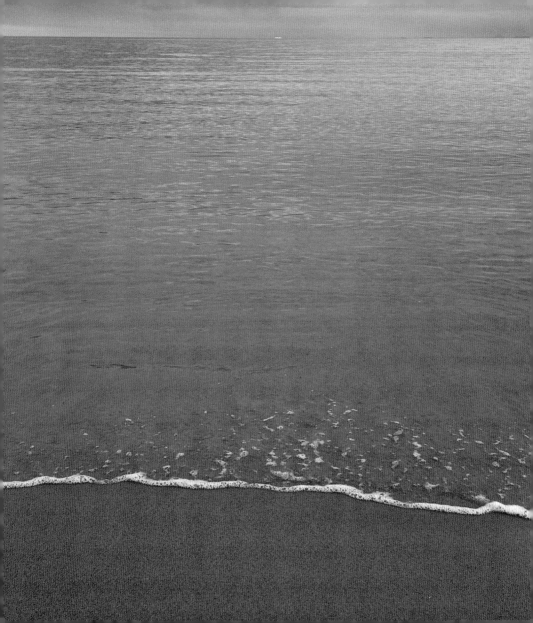

ICEBERG OFF BAFFIN ISLAND (OVERLEAF) / *Baffin Bay, Canadian Arctic*
On a luminous evening off the northern coast of Baffin Island, a symmetrical turquoise iceberg rides south on the Canadian Current. Calved from a glacier in northern Greenland, the iceberg will eventually drift south through Davis Strait into the Labrador Sea and the North Atlantic Ocean.

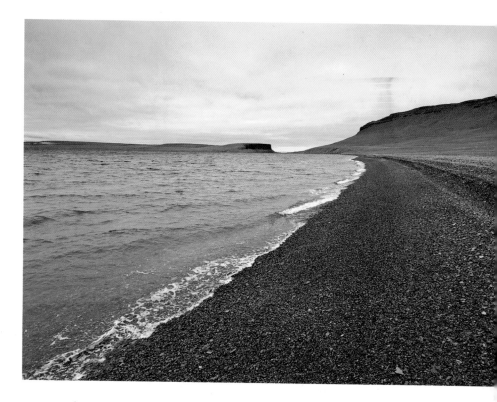

ARCTIC BEACHES (LEFT AND ABOVE) / *Baffin Island and Beechey Island, Nunavut*
Frigid waters lap the sandy, stony beaches of the Canadian Arctic. In a few short weeks the seas will freeze, the snow will fly, and the long polar night will set in.

KAYAKER AMONG THE FLOES
Devon Island, Northwest Passage
A kayaker navigates among the ice floes off the coast of Devon Island in the Northwest Passage. The Inuit invented kayaks, making them with driftwood frames and animal skin coverings. These long, narrow, swift vessels were ideally suited for hunting seals and walruses in frigid arctic waters. The word kayak means "hunter's boat" in Inuktitut.

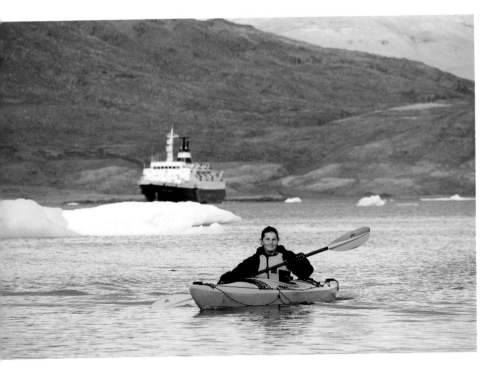

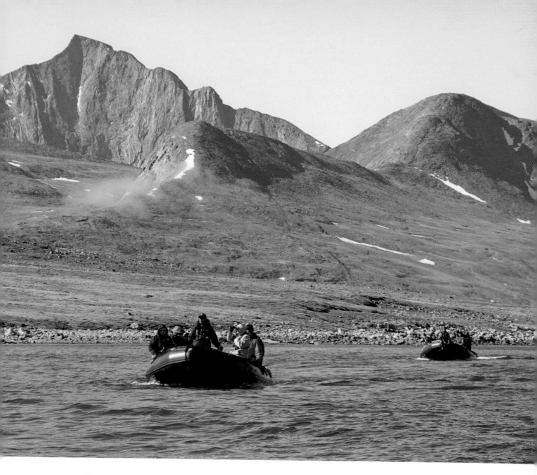

INUIT GUIDES AND PASSENGERS

Torngat Mountains, Nunatsiavut

Cruise North Expeditions Inuit staff members guide Zodiacs full of passengers to shore for an excursion on the land. Passengers have daily outings with professional experts in Inuit culture, arctic history, biology, botany, ornithology, and marine mammalogy.

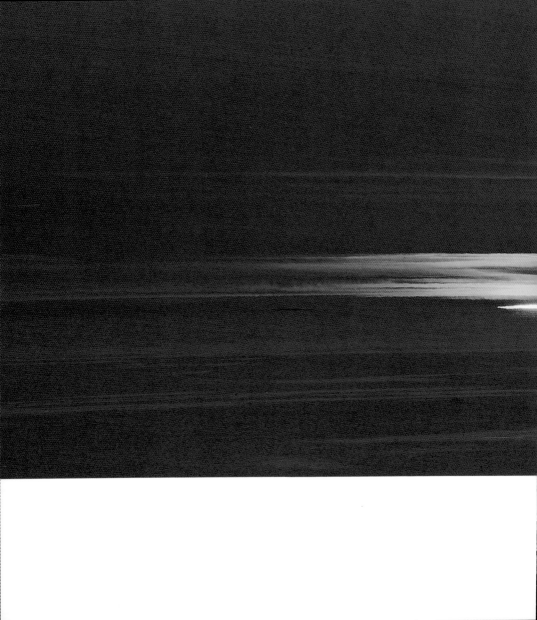

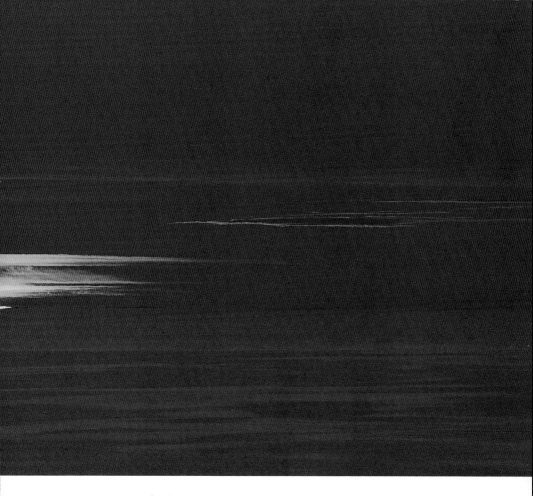

Midnight Tapestry / *Hudson Strait, Canadian Arctic*

Sailing through Hudson Strait on a fine summer evening, I faced west towards the last light of day. Night was falling, but rather than sink into the sea, the sun rolled slowly along the horizon, dipping ever deeper until just the top of the golden orb shone above the edge of the earth. At that moment the colors and textures of the water, the sun, and the sky appeared to be just like textile art woven on a loom.

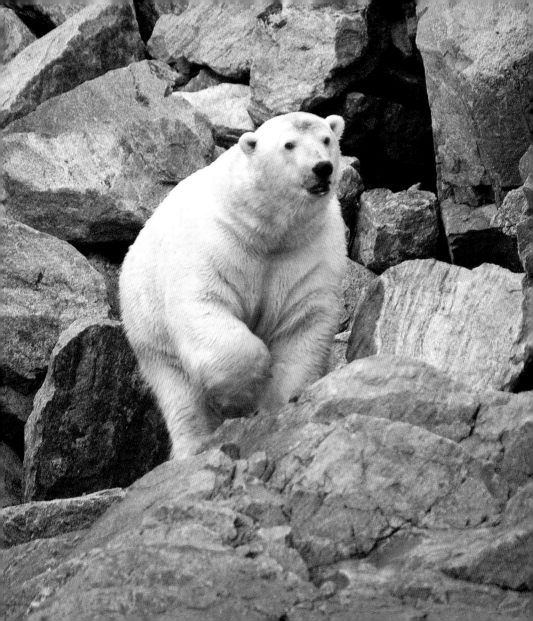

THE WILDLIFE

If I wanted caribou I'd go up to the mountains; if I wanted coloured fox,
I went up to the mountains; in the delta I get mink, muskrat;
but I never make a big trapper. I just get enough for my own use for the coming year.
Next year the animals are going to be around there anyway, that's my bank.

—BERTRAM POKIAK, TUKTOYAKTUK

MONARCH OF MONUMENTAL ISLAND (PRECEEDING PAGE) / *Davis Strait, Canadian Arctic*

A massive male polar bear approaches across the colorful cliffs of Monumental Island. Some thirty miles off the coast of Baffin Island, Monumental is a large rock surrounded by ocean. It juts directly from the sea, and a few rough rocky ledges a dozen feet or so above the waterline provide the only semblance of level ground. This otherwise unknown barren chunk of rock is a favorite resting spot for walrus, and their presence in turn attracts polar bears.

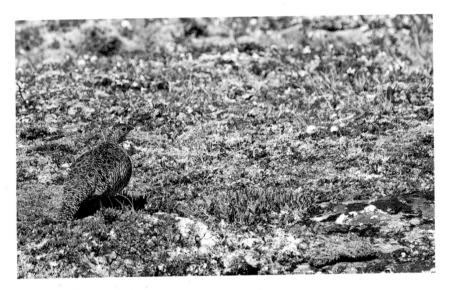

CAMOUFLAGE / *Nunavut, Canadian Arctic*

Rock ptarmigan blend in with their mottled tundra habitat so well they are almost impossible to see. In winter, they turn completely white except for their coal black eyes.

BREAKING THE SURFACE / *Hudson Strait, Canadian Arctic*

The ice was in motion all around us and threatened to close the narrow lead of open water. I was watching the closing gap, calculating our chances of escaping, when this seal broke the surface and fixed me with an inquisitive stare. For a moment we watched each other, and then he slipped below the surface just as we emerged from the icy grip of the floes.

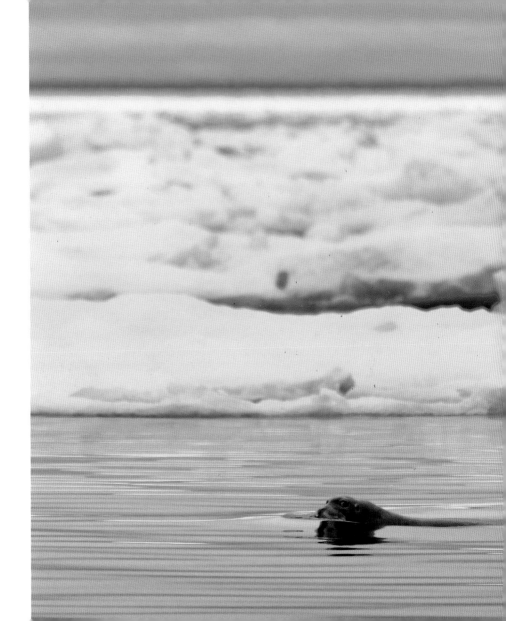

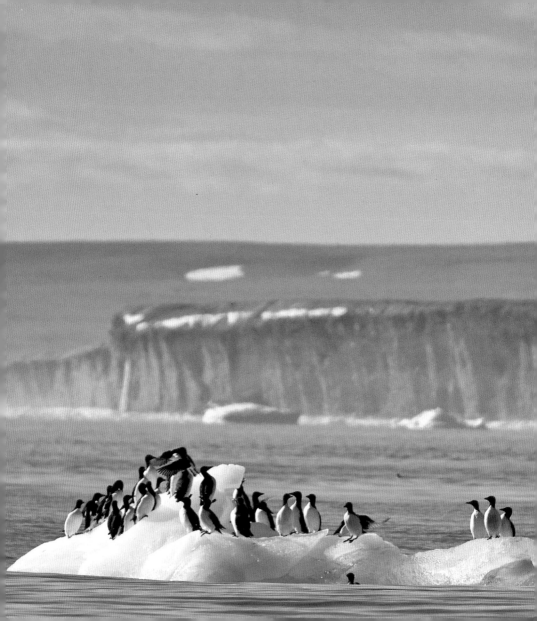

A GATHERING OF MURRES
Ungava Bay, Canadian Arctic
The thick-billed Murre is among
the deepest diving birds, regularly
descending to depths of more than
300 feet, and occasionally below 600
feet. It can remain submerged for
more than three minutes. Murres
congregate in the eastern arctic by
the hundreds of thousands, and
these cliffs host the largest murre
breeding colonies in the world.

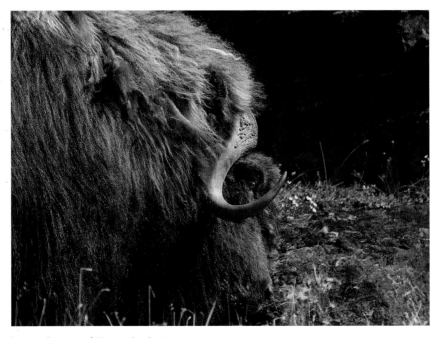

ICE AGE SURVIVOR / *Nunavut, Canadian Arctic*
Muskox are true Ice Age survivors. During the Pleistocene period, they wandered across the
Bering Land Bridge to populate Arctic North America alongside the woolly mammoth and
the saber-toothed cat. While those species are extinct, the adaptable muskox endures.

TUSKERS / *Nunavut, Canadian Arctic*
Walruses use their tusks for a variety of reasons, including hauling their
enormous bodies out of the frigid waters and onto the ice floes. The tusks are
found on both males and females. For some reason Atlantic walrus have shorter
tusks than Pacific walrus, whose tusks average about three feet in length.

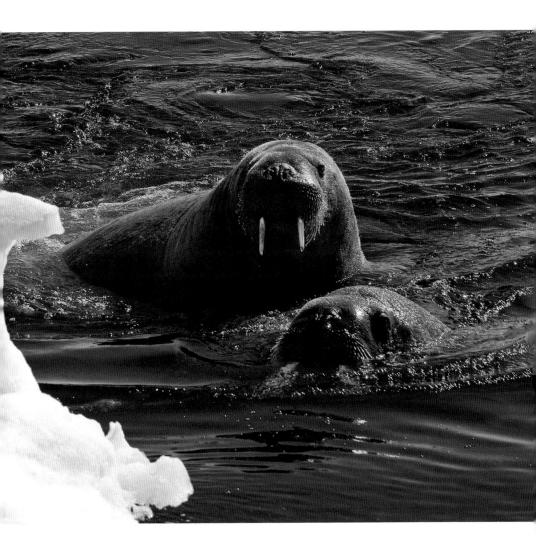

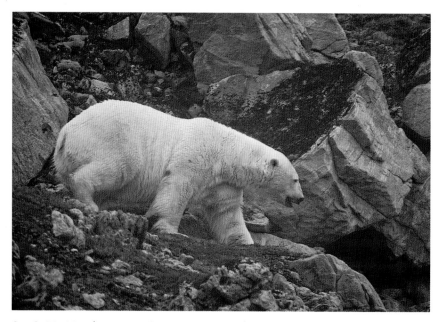

OUT OF THE MIST / *Nunavut, Canadian Arctic*
A large polar bear strides through the mist across the tundra. The
bear's thick white coat provides camouflage in snow and ice, but under
their fur, polar bears have black skin that absorbs sun's warm rays.

THE CLIFF DWELLERS / *Cape Wolstenholme, Nunavik*
Each year murre couples return to the exact same few square inches
of cliff, where the female lays a single egg on a tiny ledge. She then
arranges pebbles and other debris around the egg to prevent it from
rolling off and falling hundreds of feet to the sea below.

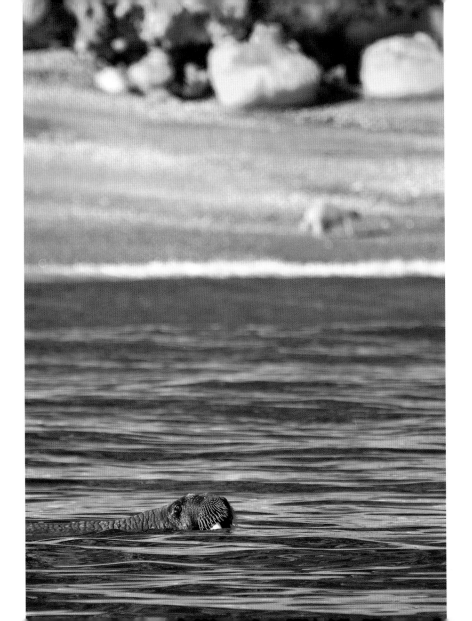

WALRUS AND POLAR BEAR / *Ungava Bay, Canadian Arctic*
While traveling by Zodiac along the coastline in Ungava Bay, Nunavut, I spotted a polar bear strolling down the beach. Just as I was about to photograph him, I heard a loud splash immediately to my left, and I watched as an enormous walrus broke the surface. What an incredible chance to place two of the Arctic's largest creatures in the same frame! I quickly recomposed the image and hit the shutter before this once-in-a-lifetime opportunity passed.

MURRES IN FLIGHTR / *Nunavut, Canadian Arctic*
Six murres race their reflections across the placid waters of Hudson Strait off the south coast of Baffin Island.

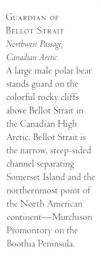

GUARDIAN OF
BELLOT STRAIT
Northwest Passage,
Canadian Arctic
A large male polar bear
stands guard on the
colorful rocky cliffs
above Bellot Strait in
the Canadian High
Arctic. Bellot Strait is
the narrow, steep-sided
channel separating
Somerset Island and the
northernmost point of
the North American
continent—Murchison
Promontory on the
Boothia Peninsula.

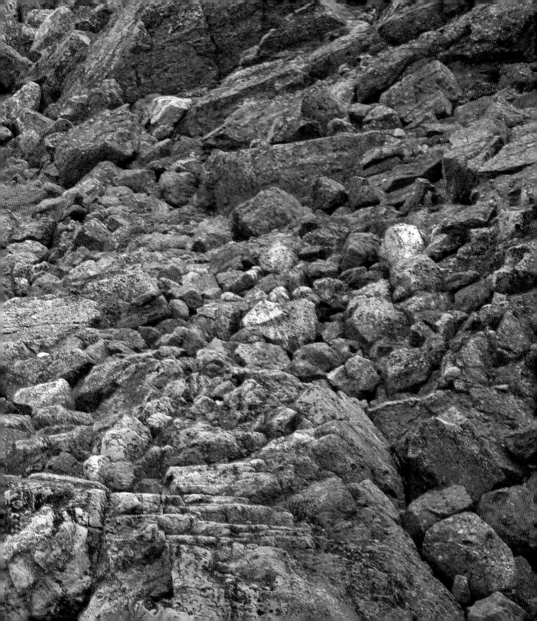

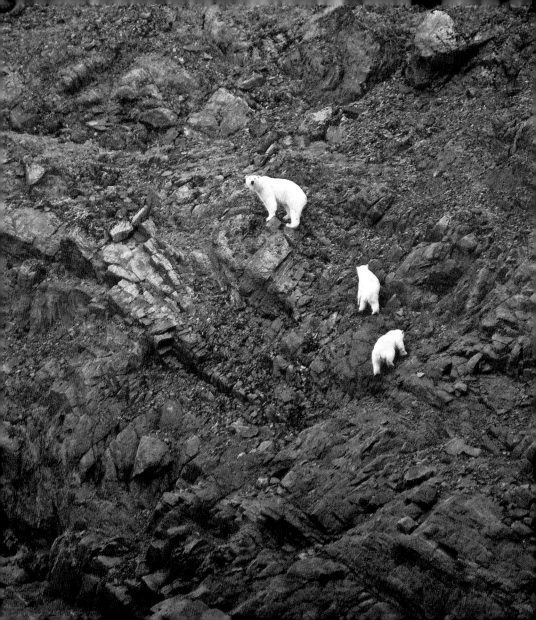

THE THREE BEARS / *Northwest Passage, Canadian Arctic*
A mother polar bear leads her two cubs up the steep rocky cliffs
rising from Bellot Strait in Canada's Northwest Passage.

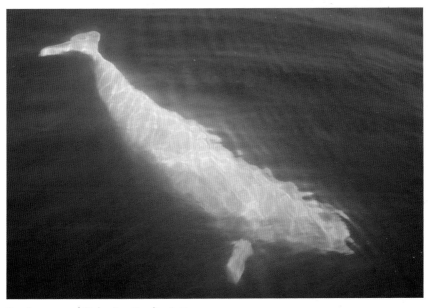

THE APPARITION / *Hudson Bay, Canadian Arctic*
Traveling in a Zodiac near the mouth of the Churchill River in western Hudson Bay, I found myself
surrounded by beluga whales. Like pure white ghosts, the fifteen-foot-long creatures would rise from the depths
and reach the surface, only to sink out of sight once again.

SURF'S UP (OVERLEAF) / *Ungava Bay, Canadian Arctic*
A polar bear wades through the crashing surf as he approaches the shoreline of an island in Ungava Bay.
Spending most of their lives at sea, polar bears are officially classified as marine mammals, and their Latin
name, *Ursus Maritimus*, literally means "Sea Bear."

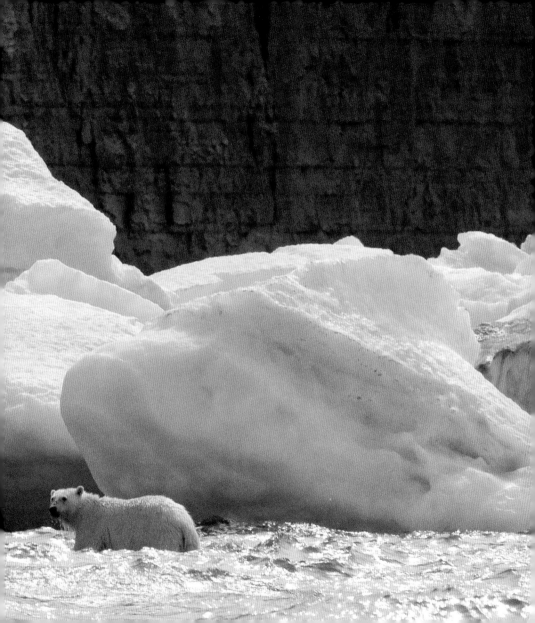

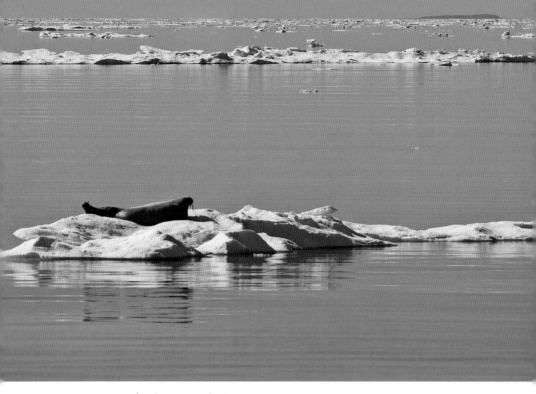

Lounging About / *Hudson Strait, Canadian Arctic*
The walrus plays a prominent role in the Inuit culture. For centuries they have hunted the walrus for its meat, fat, skin, and bone. In the 19th and early 20th centuries, the walrus was hunted commercially for blubber and ivory and its numbers declined rapidly but have since rebounded.

Cliffs of Cape Wolstenholme / *Nunavik, Canadian Arctic*
Rising 1,000 feet above the waters where Foxe Channel, Hudson Bay, and Hudson Strait come together, these wind and wave-lashed cliffs are the nesting place of one of the world's largest colonies of thick-billed murres. For some 4,000 years different peoples, including the nomadic ancestors of the Inuit, have inhabited the coast and islands of this area.

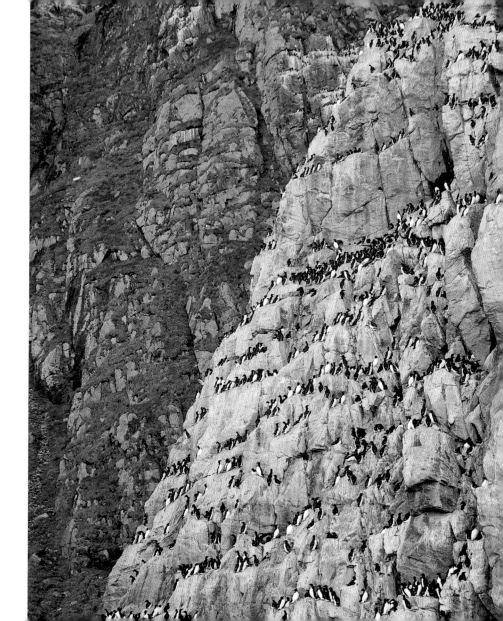

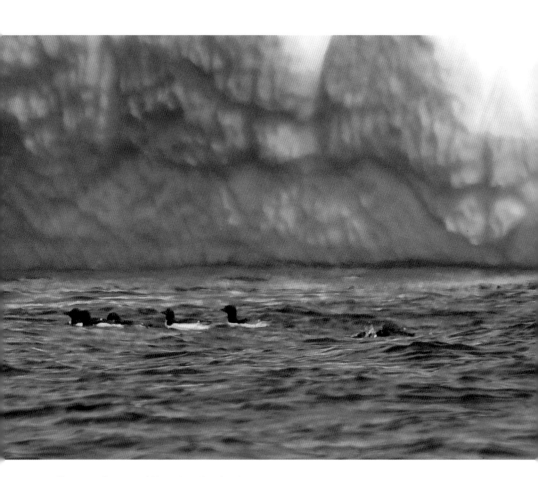

BEAUTIFUL SWIMMER / *Ungava Bay, Canadian Arctic*
While threading our Zodiac through ice floes in Ungava Bay, we made a turn and found ourselves in the same lane of open water as this polar bear swimming through a flock of thick-billed murres. It was thrilling to hear his breath as he swam, and to watch his powerful stokes propel him through the icy swells.

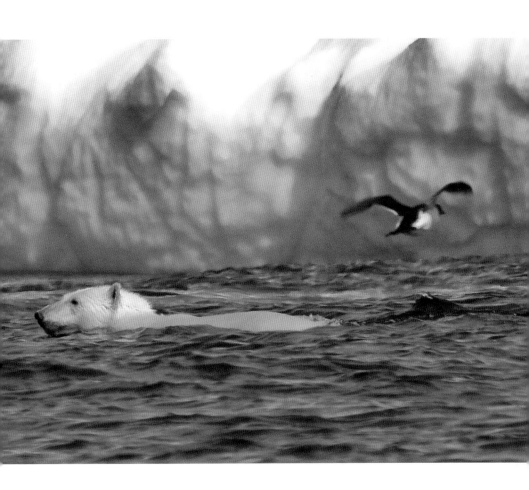

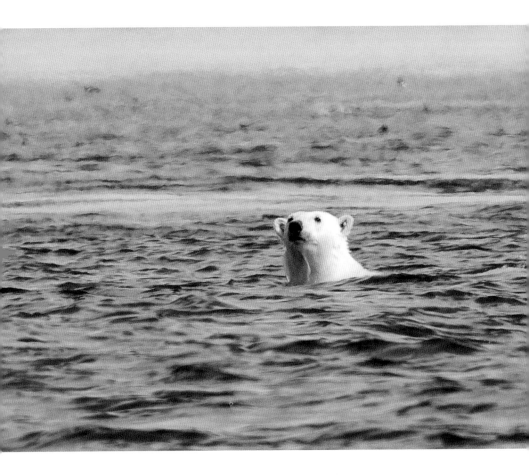

THE SPY HOPPER / *Ungava Bay, Canadian Arctic*
I have often seen killer whales rise above the surface to take a long look at something that captures their attention. It's called "spy hopping," and when you are that object of interest, it puts your relationship with your viewer in a whole new perspective.

THE BEACHCOMBER / *Nunavut, Canadian Arctic*

Strolling along the edge of the sea, a polar bear wanders the shores of an Arctic island. Above him, giant barn-sized blocks of ice sit on the beach where they were stranded by the tide. In summer, polar bears wait for the sea to freeze by scavenging beaches for whale and seal carcasses, and by searching for seabird eggs and fledglings fallen from the nesting cliffs above.

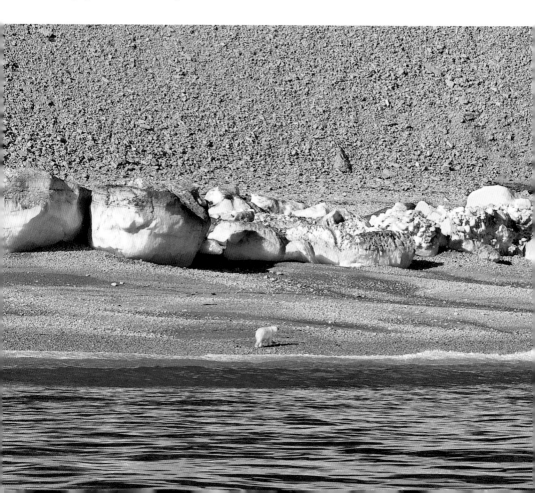

THE ICE BEAR (OVERLEAF) / *Ungava Bay, Canadian Arctic*
A polar bear moves gracefully across jumbled blue ice blocks. Polar bears are the largest (an adult male can weigh up to 1,500 pounds) and most carnivorous members of the bear family, feeding mainly on a diet of ringed and bearded seals. True denizens of the Arctic Ocean, polar bears have evolved to occupy a specific ecological niche. They are superbly adapted for extreme cold temperatures, for moving swiftly and surely across snow and ice, and for swimming long stretches of open water.

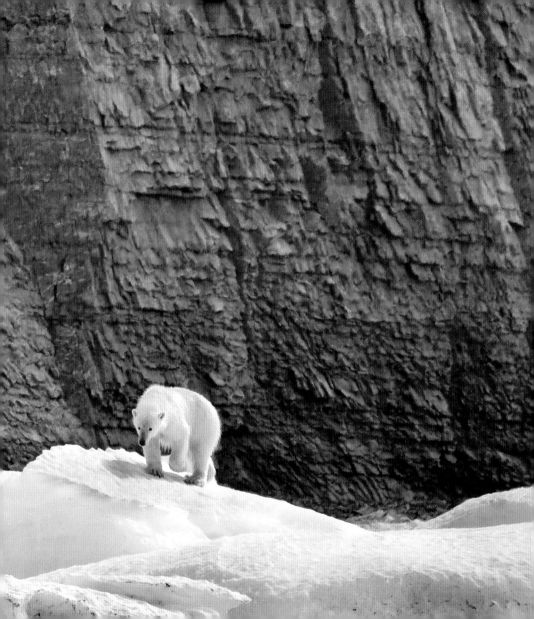

THE PEOPLE

*We are a people barreling wholeheartedly
ahead into a more prosperous world.
Our needs are great, but so is our might.*

—PITA AATAMI, KUUJJUAQ

ON THE ICE TRAIL (PRECEDING PAGE)
A young Inuit hunter on the sea ice off the coast of Nunatsiavut.

UP IN THE AIR / *Kuujjuaq, Nunavik*
An Inuit flight attendant tends to passengers aboard an Air Inuit aircraft. A wholly owned subsidiary of Makivik Corporation, Air Inuit trains and employs Inuit as pilots, flight attendants, ground crew members, and other important positions in the aviation industry.

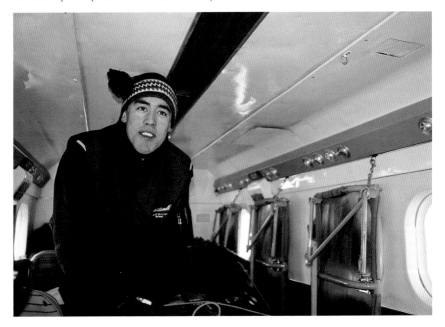

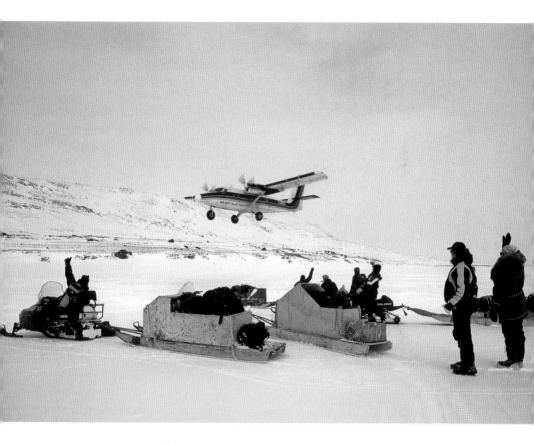

LIFELINE OF THE NORTH / *Abloviak Fjord, Nunavik*

Air Inuit, a wholly owned subsidiary of Makivik Corporation, has become the true lifeline of the 14 communities of Nunavik. In a region with no roads or rail, Air Inuit provides daily passenger and freight service along the east coast of the Hudson Bay and through the Hudson Straight and Ungava Bay. It is also the link between villages, southern Canada, and the world. With bases or agents in all Nunavik communities, Air Inuit employs over 600 people.

Community Spirit / *Kuujjuaq, Nunavik*

The community of Kuujjuaq comes together for a traditional feast in the village gymnasium. Historically, the Inuit lived in widely scattered nomadic family groups, coming together occasionally to share in the bounty of the land and sea. Today, although they live in permanent villages, it is still a cherished custom in Inuit communities to gather together for meals and celebrations.

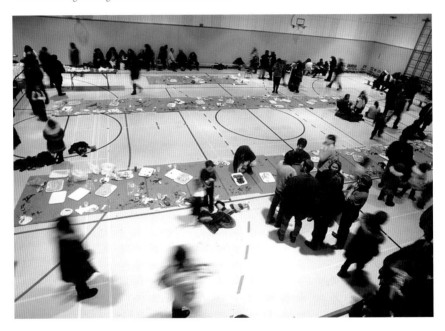

Inuit Hunter on the Sea Ice / *Nunatsiavut, Canadian Arctic*

The Labrador Sea in winter is a forbidding place. The wind slices the snow like a sculptor's chisel, the cold, immaculate light falls from an austere blue sky, the temperature plumbs the very depths of the thermometer, and polar bears stalk the ice hunting for seals. Today, the Inuit still travel over the frozen surface of the sea in the timeless pursuit of game.

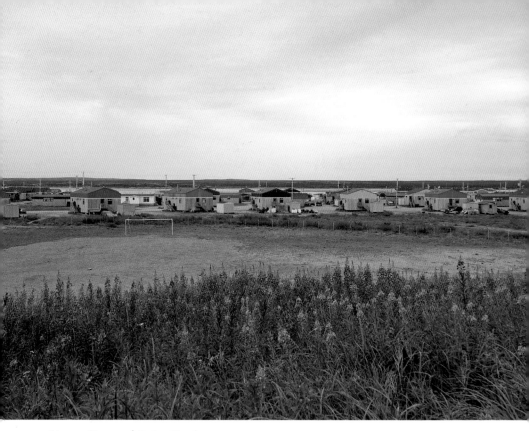

MODERN HOUSING / *Kuujjuaq, Nunavik*
Modern single-family homes are now common in Inuit villages across the north. Given Nunavik's young and rapidly growing population, providing adequate housing remains a priority for Makivik, the federal and provincial governments, and the Kativik Regional Government.

WOOD AND SOD / *Pond Inlet, Nunavut*
An elderly woman walks near a wood and sod house of the kind commonly inhabited up until the 1960s. To make these homes the Inuit would dig a hole in the ground and then pile rocks and sod around the outside to make the walls. Pieces of wood were used for the floor, walls, and roof, which was then covered with sod and perhaps, as in this case, with a tarp.

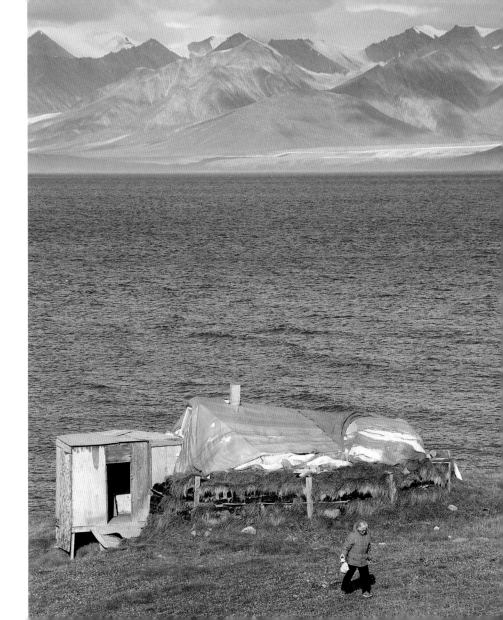

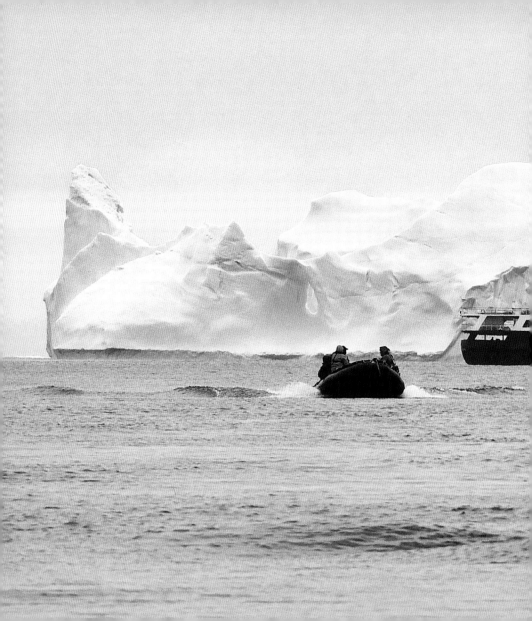

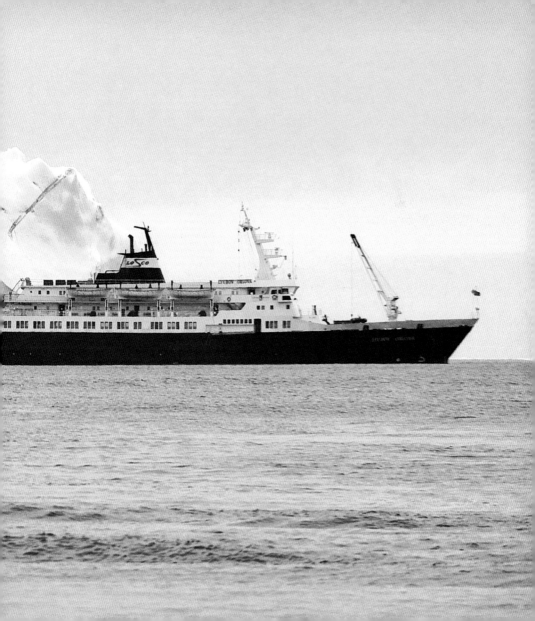

DWARFED BY THE ICE (PREVIOUS PAGE) *South Coast of Baffin Island, Nunavut*
The *Lyubov Orlova*, a passenger ship owned and operated by the people of Nunavik through the Makivik
Corporation and Cruise North Expeditions, is overshadowed by a massive iceberg off the coast of Baffin Island.

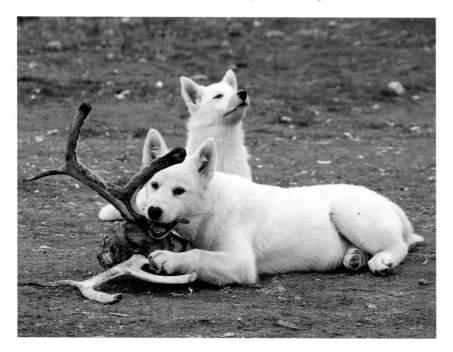

SIBLING SLED DOGS
Qikiqtarjuaq, Nunavut
Strolling through the Inuit village of
Qikiqtarjuaq, situated on an island off the
coast of Baffin Island, I encountered these
wolfish-looking siblings politely taking turns
gnawing on a caribou skull.

SHOWING THEIR HOMELAND
South Coast of Baffin Island, Nunavut
Cruise North Expeditions, owned and operated as a joint
venture by the people of Nunavik through the Makivik
Corporation, places a high priority on employing
Inuit and runs an ambitious and successful youth
training program on the ship each summer.

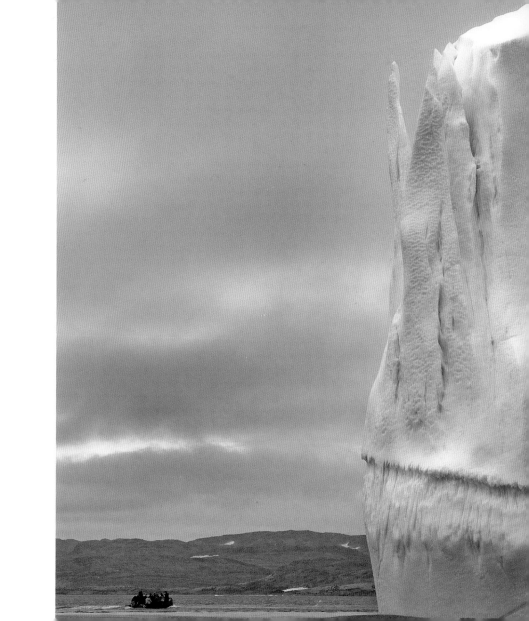

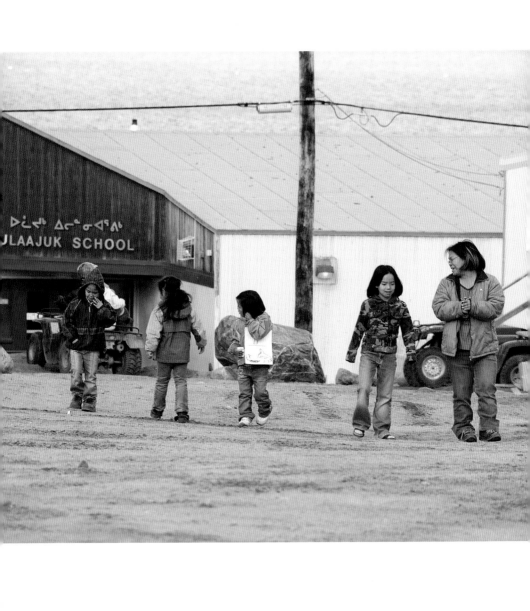

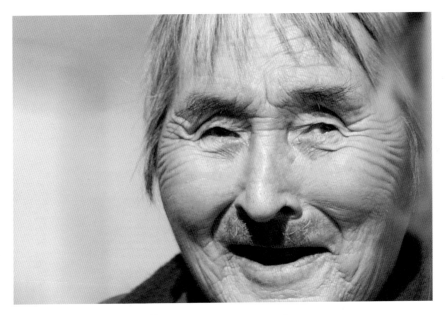

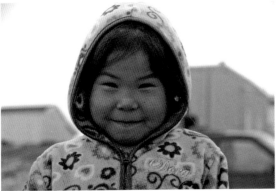

Portraits of the Arctic

LEFT: Schoolchildren in
Pond Inlet, Nunavut.
ABOVE: An elder in
Kangiqsujuaq, Nunavik.
BELOW: A young girl in
Qikiqtarjuaq, Nunavut.

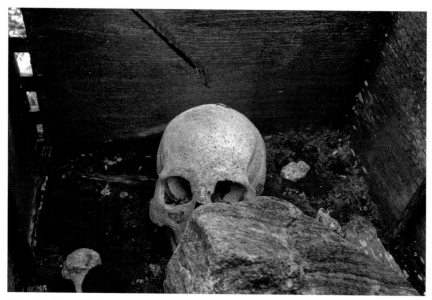

WHALER'S GRAVE / *Kekerten Whaling Station, Baffin Island*
At this long-abandoned station dozens of makeshift graves cover the rocky slope, most just small rectangular boxes filled with the bones of the men who lived, worked, and died here. Wood was scarce, so the survivors made the bodies fit into tiny crates and left them out in the open.

STONE MEAT CACHE / *Nachvak Fjord, Nunatsiavut*
Stone meat caches line the shore at Nachvak Fjord in the Torngat Mountains. Though they look ancient, caches like these were used by Inuit hunters into the mid-20th century.

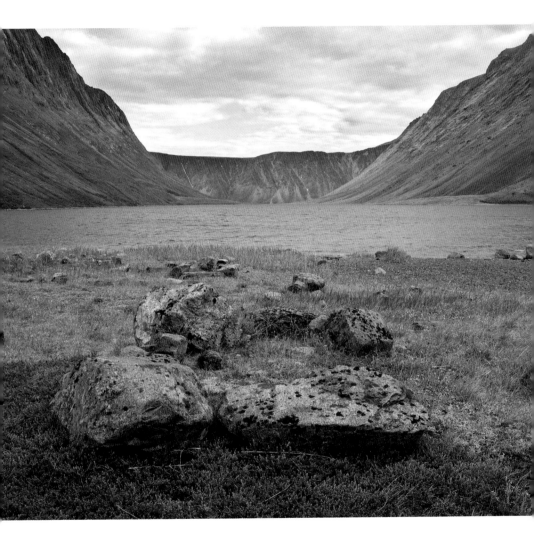

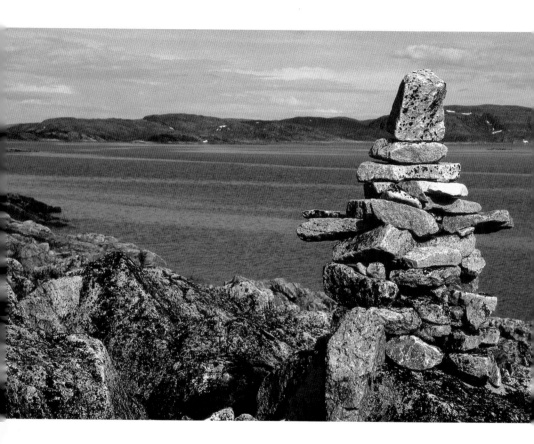

INUKSHUK / *Cape Dorset, Baffin Island*
The Inuit of the Canadian Arctic constructed stone figures such as this inukshuk, which literally means 'the likeness of a human.' Constructed from whatever stones were to be found at hand, each one is unique. They were built as navigation aids, to identify hunting and fishing grounds, and to mark sacred places and serve as portals to other worlds.

DAVIS AND TOMMY

Pangnirtung, Nunavut

Davis and Tommy led me to their favorite place in town, the playground next to the elementary school. There they performed like Olympic gymnasts, flying above the ground, swinging quickly from ring to ring.

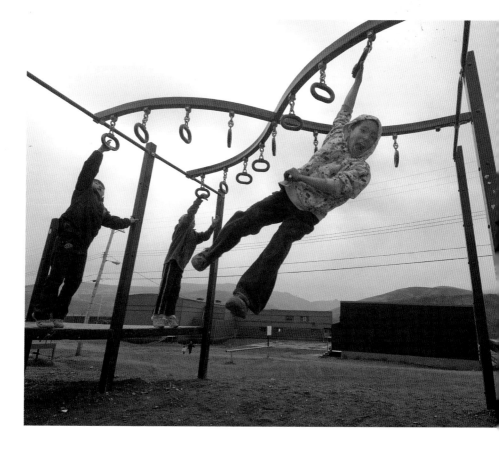

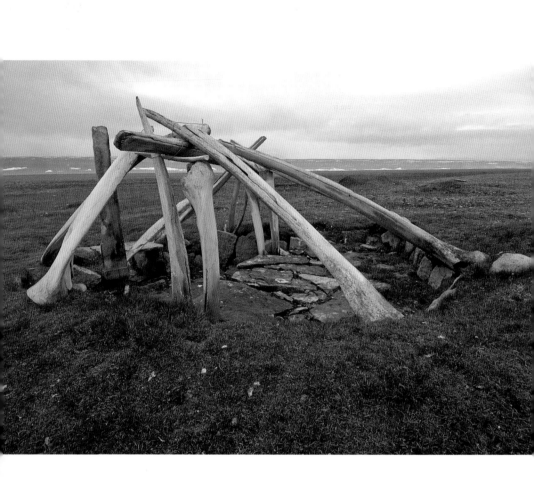

ANCIENT DWELLING

Cornwallis Island, Northwest Passage

A Thule whalebone hut stands on the shore of Cornwallis Island in the Canadian High Arctic. The Thule were the ancestors of the Inuit and their whaling-based culture developed in coastal Alaska and expanded eastwards across the Canadian Arctic, eventually reaching Greenland by the 13th century.

ICY GRAVE IN THE POLAR DESERT
Beechey Island, Northwest Passage
A headstone stands over the grave of one of Sir
John Franklin's sailors who died here in the winter
of 1845-46, most likely of lead poisoning from
improperly sealed cans of food. Frozen in time,
to this day the bodies buried here are perfectly
preserved by the permafrost.

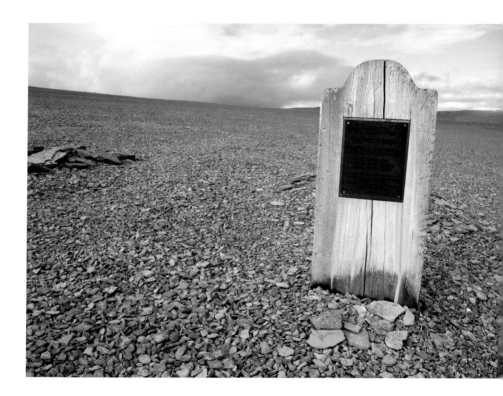

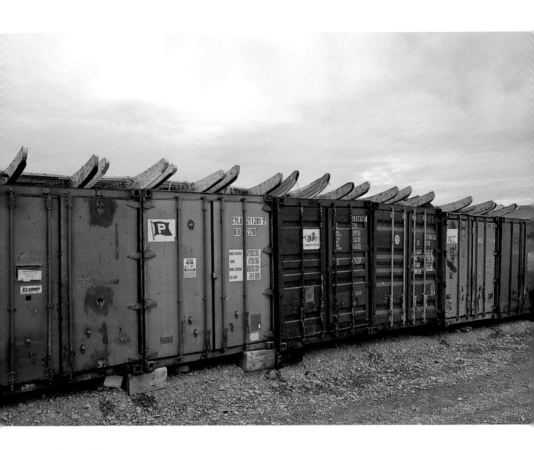

Old and New

Resolute, Canadian Arctic

Dog sleds sit atop cargo containers in Resolute. Symbols of the old ways and the new, dog sleds and cargo containers both have their place in modern Inuit society. While the snowmobile remains popular, dog sledding is enjoying a revival. And although the people depend upon the local environment for much of their subsistence, many needed supplies arrive from the south by cargo sealift.

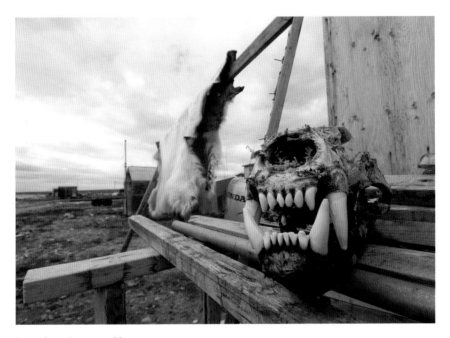

POLAR BEAR SKULL AND HIDE
Gjoa Haven, King William Island
Remains of a freshly killed polar bear dry
outside an Inuit hunter's home. Roald
Amundsen spent two years in Gjoa Haven
during his first successful completion of the
Northwest Passage from 1903-1905.

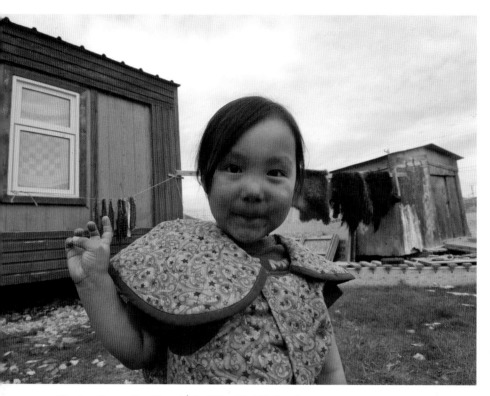

NETSILIK GIRL IN GJOA HAVEN / *King William Island, Northwest Passage*
A young Inuit girl stands in front of muskox and bear hides in Gjoa Haven. During his traverse of the Northwest Passage, Roald Amundsen learned essential survival skills from the Netsilik Inuit that he later used to reach the South Pole.

HUNTING CAMP / *Mansel Island, Nunavut*

A large island in the far northeastern corner of Hudson Bay, Mansel lies 35 miles off the northern coast of Nunavik, and is a favorite hunting and fishing destination for Inuit families from Ivujivik, Povungnituk, and other villages along the coast.

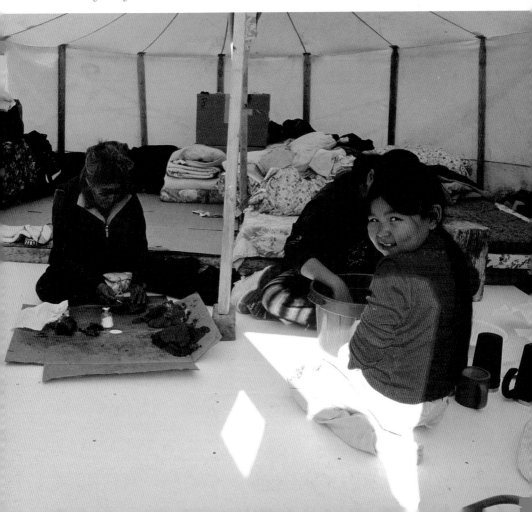

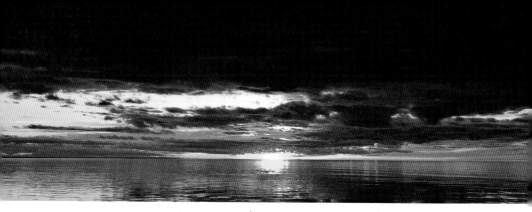

ARCTIC SUNSET / *Ungava Bay, Canadian Arctic*

Like a great orange fireball, the sun sinks into the icy waters of Ungava Bay in the Canadian Arctic. Just as it slips below the horizon, it illuminates the undersides of dark storm clouds riding the sky overhead.

ACKNOWLEDGEMENTS

THANKS GO TO Dugald Wells, president of Cruise North Expeditions, the Inuit owned and operated cruise line based in Kuujjuaq, Nunavik, for graciously hosting me aboard the expedition vessel *Lyubov Orlova* on many journeys throughout the arctic. Most of the photographs in this volume were taken while I was on Cruise North expeditions. Thanks too to the Cruise North Expeditions staff for making each journey to the North so informative, entertaining, and just plain fun.

My gratitude is extended to the Makivik Corporation, a non-profit organization owned by and operated for the benefit of the Inuit of Nunavik, for the assistance they have given me over the years. For three decades Makivik, which owns profitable subsidiary companies such as Air Inuit and Cruise North Expeditions, has been a leader within Canada and the world in successfully combining aboriginal rights, political negotiation, and business acumen into successful business and economic initiatives contributing to the national, provincial and regional economies.

I also wish to thank the staff of Torngat Mountains National Park and the Nunatsiavut Transitional Government for hosting me on a memorable and adventurous winter expedition to that beautiful and fascinating part of the world.

And closer to home I thank Eli Burakian for his hard work and expertise preparing these images for publication. Dede Cummings of DC Design never ceases to amaze me, and her beautiful design showcasing my photographs and words in this volume is no exception. Thanks also to Carolyn Kasper for preparing the map, to Caroline Cannon for her business and organizational skills, and finally and most of all to Mary Gorman for, well, everything.